D1233736

Victoria and Albert Museum

Burmese Art

John Lowry

London Her Majesty's Stationery Office 1974

Front cover illustration: plate 2

ISBN 0 11 290179 4

Contents

21 Two goddesses (*devis*). Glazed terracotta. Possibly late 15th century

22 Wall Tile. Glazed earthenware. Probably late 18th or early 19th century

23 Two pottery Vessels. Glazed earthenware. Probably 19th century

24 The Buddha Shakyamuni. Terracotta plaque. Probably about 12th century

25 Embroidered Hanging (*kalaga*). Probably 19th century

26 Embroidered Hanging (*kalaga*). Probably late 19th century

27 Part of a *lùn-taya* Fabric. 19th century

28 Headdress. Gold set with semi-precious stones. Possibly early 15th century

29 Betel Nut Container. Gold and filigree work. Probably 19th century

30 Box, Cup and Bracelets. Gold set with diamonds and rubies. Probably first half of the 19th century

31 Pectoral Cross. Gold set with rubies. About 1870

32 Ceremonial Bowl. Embossed gold and semi-precious stones. Probably mid 19th century

33 Table Centrepiece. Embossed silver. Probably late 19th century

34 Bowl. Embossed and engraved silver. Probably late 19th century

35 Three Swords. Probably 19th century

36 Bowl. Lacquer with design in black, yellow and green. Probably about 1910-20

37 Nest of six Cylindrical Boxes and one Tray. Red and black lacquer. Probably 19th century

38 Harp (*saùng-gauk*). Black and gold lacquer. 19th century

39 Panel from a Chest. Wood with black lacquer relief decoration. 19th century

40 Mirror. Carved and lacquered wood set with pieces of coloured glass. Probably second half of the 19th century

41 Doors and Door Frame. Wood with pieces of mirror set in lacquer. Probably mid 19th century

42 Two Door Panels. Carved wood. Probably mid 19th century

43 Gong Stand and Gong. Carved wood and brass. Late 19th century

Index

Introduction

The art of Burma does not seem to have attracted the attention of Western scholars quite as much as that of other important countries in South-east Asia. Except for the Pagan period (A.D. 1044–1287)*, therefore, the detailed history of Burmese art has still to be written. It is hard to account for this curious gap in the literature of South-east Asian art history. One of the obstacles which up to now has prevented it from being filled may be the difficulty of combining the styles of several ethnic groups, such as the Shans, who have a strongly developed style of their own, into a connected narrative. As its name suggests, the Union of Burma comprises a number of constituent units; these have their own culture and traditions, which, as well as being unevenly developed, have also both influenced and been influenced by the main stream of Burmese art history. Other complicating factors are Burma's size and geography. It is the largest mainland country in South-east Asia, having an area larger than France, Belgium and Holland combined. Part of her frontiers march with those of countries having two of the most important civilizations in Asia– India in the north-west and China in the north-east. On the western side is a long coastline, while the country itself extends through 18 degrees of latitude. As a result Burma's climate ranges from snow-covered mountain peaks in the north to equatorial rain forests in the south. In between is an area having an intermediate, or dry-zone, climate corresponding roughly with that part of the central plain which lies between Shwei-bo and Prome.

It is in this region, along the middle reaches of the Irrawaddy, that some of the earliest evidence of civilization in Burma is found. This was the kingdom established in the early seventh century A.D. by the Pyus, who were a people distantly related, and speaking a similar language, to the Burmans who were to follow them eventually from the north-east. Accounts of this kingdom contained in

* Gordon H. Luce, *Old Burma – Early Pagán*, *Artibus Asiae*, *Supplementum*, 3 vols., New York, 1969.

Chinese official records, the Old and the New T'ang Histories, provide a vivid picture of life at court. The king was carried on a golden litter, men and women wore gold and silver jewelled ornaments on their hats and in their hair; women wore silk gauze scarfs and carried fans. Music and dancing were very popular and even dancers and musicians wore jewel-studded bracelets and anklets. The name of the capital, Shri Kshetra (Fortunate Field), which was also that of the Indian city of Puri in Orissa, and the discovery of Pali inscriptions at the site of the capital suggest that the culture of the Pyus was somewhat Indianized. Their religion was certainly Buddhism, since a large white image of the Buddha which was erected in their capital is mentioned in the Chinese histories. It is probable that Theravada sects predominated but the existence of Avalokiteshvara figures, some of which had four arms (see below), shows that there were also followers of Mahayana. However, the religious toleration which was almost universal practice in India and Southeast Asia allowed Hinduism to exist side by side with Buddhism. Evidence for this is given by the name of another important Pyu city, which is Beik-thanò-myó, meaning Vishnu city, as well as the existence of sculpture representing Hindu dieties (see below). In the ninth century A.D. the Pyu kingdom came to an end, leaving behind it many architectural monuments including characteristically shaped *thupas*, sculpture in bronze and stone, and examples of minor arts executed with a high degree of skill. Much of the stone sculpture shows characteristics similar to the late Gupta or post-Gupta style in India with the figure of the Buddha often seated with his crossed legs placed one on top of the other (*virasana*) and wearing robes which appear to cling so tightly to the body that they are indicated almost entirely by a thin line at their edge. This treatment of drapery was also used on a Pyu four-armed figure of Vishnu, who is shown holding a club and standing on a *garuda* (mythical bird), but here the style may be closer to that found during the Pallava period in south India at sites such as Mahabalipuram. A four-armed bronze figure, identified as Avalokiteshvara by the Dhyani-Buddha Amitabha in his headdress, has a thick sash prominently knotted on his left hip in a way which is remarkably similar to Gupta Bodhisattva figures. This figure also has a prominent sacred cord (*upavita*) and this seems to be found on a large proportion of bronze Bodhisattva figures at present ascribed to the Pyu culture. These are often shown seated in a variation of the *rajalilasana* posture with the right hand resting on the raised right knee and, with their elaborate hair styles, coronets and jewellery, appear to be linked stylistically more to the early Pala period in India (see pl. 18).

At the same time as Shri Kshetra there existed in the delta area to the south another state which almost certainly began before it and lasted some time after its disappearance. This was the kingdom of the Mons, who between the seventh and the ninth century A.D. were probably the most cultured people in the south-western part of South-east Asia. Although capable of winning battles, they seem to have been fundamentally peace-loving. However, this did not prevent them at the height of their powers from ruling an area from Pegu in the west to Lampun in the north and Lopburi in the east in a loose confederation of city-states. Ethnically the Mons were quite distinct from the Pyus, being related to similar groups belonging to areas further east. This is also suggested by their language, which is a form of Khmer. Like the Pyus, however, the Mon culture was deeply Indianized – in some respects even more so than the Pyus. Pegu, one of the chief cities of the western Mons, was also called Ussa, which can be equated with Orissa (see above). After their early contacts, the Burmans referred to the Mons as Talaings, which then, as now, was a term of disrespect. Some etymological connexion has been found between this word and the Telingana district of Andhra Pradesh in S.E. India and this may indicate the area from which the Indian immigrant traders came. Further evidence of the Mons' association with India is given by their adoption of the Hindu idea of divine kingship. Towards the end of their period of independence, about the eleventh century, Hinduism gradually became more popular. But for most of their history the Mon states, including that centred on Thahton in Lower Burma, were Theravada Buddhist. Unfortunately, little material evidence of this Buddhist culture of the western Mons, such as architecture and sculpture, has yet been found. However, perhaps some idea of what the sculpture was like may be given by the far greater amount of material belonging to the style usually associated with the Dvaravati kingdom of the eastern Mons situated in the lower Menam valley in Thailand. This shows a variety of elements, of which the Indian late Gupta style, particularly that of the cave temples of the western Deccan, forms the larger part. Buddha figures in stone and bronze, standing and seated, are often represented wearing tightly clinging robes, which in standing figures form two curved and ridged hemlines, one across the ankles and the other across the shins, while folds formed below each of the raised hands fall almost symmetrically on each side. In seated figures the *virasana* (see above) position of the legs suggests a borrowing from S.E. India, perhaps Amaravati in Andhra Pradesh, or from Ceylon.

In spite of, apparently, being capable of doing so, the Mons never created an empire for themselves and were eventually absorbed into other states (see below). In Burma, unlike the Pyus, who were kinsmen of the Burmans but who gradually ceased to be of any importance after the loss of their independence, the Mons continued to exert a positive cultural influence long after their final annexation by the Burmans. They continue to exist today as an almost completely absorbed minority in the Union of Burma but still conscious of their ancient language and culture.

Some time in the early part of the ninth century the Burmans who had been subjects of Nan-chao, situated on the high plateau of western Yunnan, broke away and set up a state of their own between Kyauk-hse and Mìn-bù. A little later they took over the small village of Pagan, which had probably been founded by the Pyus, on the left bank of the Irrawaddy and eventually made it their capital. Although the kingdom was politically somewhat unstable at first, the accession of Anaw-rahta in A.D. 1044 began a more peaceful period lasting for about 300 years, during which an unprecedented cultural and religious development took place. Because of the immense number of monuments which were built (of which about 5,000 remain) and thus the large quantity of high quality sculpture and painting which has survived, the Pagan period is usually regarded as the greatest in the history of Burmese art. It also marks the beginning of the hegemony of the Burmans which has continued in the Union of Burma today.

Anaw-rahta ascended the throne at a time when Buddhism was on the wane almost everywhere. This was partly due to military conquest, as by the Muslim armies in Bihar and Bengal and the Hindu Cholas in Ceylon, or simply by the resurgence of Hinduism, as in the Deccan and Thahton. However, Anaw-rahta chose to replace the mixture of animism and Mahayana Buddhism, which was the prevailing religion of his kingdom, with Theravada Buddhism. In so doing he probably created a refuge in which Buddhist teachers and artists from other parts of South-east Asia, North-east India and Ceylon might find an opportunity to continue their work. It is difficult to say whether many artists from these centres went to work in Pagan. It is certain that at least one great teacher, Shin Arahan, left Thahton to find work at the court of Pagan, and that the king forced many other Mon monks, as well as scholars and craftsmen, to move from the same area to the capital. There is also evidence given, not only by Indian and Nepalese bronzes which have been found there, but also by the close stylistic connexions

with the art of the Pala period in India shown in the architecture, sculpture and paintings at Pagan. But as this, like the art of the Pyus, is almost unmistakably Burmese it remains debatable as to how much of this similarity is due directly to the work of native Indian craftsmen and how much to their training of local architects, sculptors and painters.

Although many of the original buildings were probably of wood, most of the remaining architecture at Pagan is built of brick or masonry, or other durable materials. These buildings fall roughly into three groups, solid formalized relic-mounds (often called pagodas; Burmese, *zei-dis*; Pali, *cetiyas* see pls. 5, 14 and 24), centrally planned temples sometimes incorporating *zei-dis*, and axially planned temples. It is, perhaps, the first two which are the most typically Burmese with their characteristic door pediments (see pls. 1, 2 and 40) and decorated interiors (see below) often lined with images. The art of Pagan was mainly, but not exclusively, devoted to Theravada Buddhism, which found its chief means of expression through the Buddha figure. Seated images often show him in meditation posture with the soles of both feet uppermost (*vajrasana*), instead of *virasana* (as in some Pyu sculpture), against a semi-architectural background which sometimes includes two birds facing outwards and holding a sprig of foliage or a string of jewels in their mouth. These, and the Buddha's tightly fitting robe with a flap over the left shoulder (see pl. 7), may suggest a stylistic relationship with North-east India. Crowned figures, which can also be traced to the same area, appear for the first time during the Pagan period, some of them having four flamboyant ribbons extending from the headdress, similar to those belonging to the bronze shown in plate 12. But it is, perhaps, through its wall paintings that Pagan can claim to make its greatest contribution to the history of Buddhist art. The flexibility of the technique enabled painters to express a wide range of complex ideas through involved decorative schemes. These included not only Theravada subjects such as stories of the Buddha's former lives (see pls. 22, 25, 48 and 49), and Mahayana figures such as those of Avalokiteshvara and Manjushri, but also paintings which are unmistakably tantric, and representations of Hindu deities such as Shiva and the Boar incarnation of Vishnu. The paintings, moreover, have the additional interest of giving some idea of how the interiors of temples and monasteries in North-east India may have looked during the late Pala period before they were destroyed during the Muslim invasions.

At present, many of the details forming part of the development of Burmese art from the end of the Pagan period to the eighteenth century are missing. As a result, it can only be traced in a somewhat faint outline. In the post-Pagan period a greater variety of images arose while still keeping within Theravada iconographical conventions. This may have been due to several causes including the Mon temporary return to independence in the south, the increase in Shan influence in the north and, during the sixteenth and eighteenth centuries, the wars with Thailand. In the south, Buddha figures seated in *virasana* continued to be made, some of which had tall projections (sometimes described as representing flames or a lotus bud, see pls. 2, 12, 13 and 17) attached to the top of the Buddha's head. In the north Shan states, however, bronze Buddha figures have been excavated which are clearly related to similar figures from north Thailand. Another, possibly more Burmese, style seems to have been popular in the Pagan area. Here the variety of thrones on which the Buddha is shown seated, already evident in the eleventh and twelfth century sculptures, was developed by Burmese craftsmen in contrast to the single, or double, lotus throne which had become almost conventional in India and Thailand. Two of the most characteristic of the Pagan thrones were the stepped and waisted design, similar to those shown in plates 1 and 17, and the hour-glass shape illustrated in plate 13, each sometimes having a slightly convex top.

By the seventeenth century two other traits which originated much earlier became firmly established in the representation of Burmese Buddha images. One of these was the rendering of the fingers and toes as equal in length, similar to some images from North Thailand (see pls. 2, 12, 13 and 17), and the other was a greater elaboration of the side ribbons on the headdress of Buddhas in royal costume and some other figures (see pls. 10 and 12). Thus, the characteristic, but not exclusive, form of the Buddha image gradually developed by the combination in the same figure of several elements; these were the tall projection on the *ushnisha*, fingers and toes of equal length, the markedly waisted (and also sometimes stepped) throne and, in crowned images, highly elaborate side-ribbons attached to the headdress. Usually these figures continued to be shown wearing the tightly clinging robes associated with sculpture belonging to the Gupta period in India (see above).

However, towards the end of the eighteenth, or in the early part of the nineteenth, century a new more naturalistic style arose. The Buddha's robes were rendered in loose folds often having a promi-

nent decorated flap over the left shoulder (see pl. 8), while the fingers and toes were shown of unequal length. In addition, a wide band or fillet, also often decorated, was added to the hairline above the forehead (see pls. 8, 9 and 15).

This brief discussion, which is almost entirely concerned with the Buddha image, obviously leaves out a great many highly relevant subjects, while others are mentioned only in passing. These include not only other media and techniques of artistic expression and the minor arts, but also later developments in architecture and painting. Moreover, no account has been given of the changing political groupings and status of sub-states such as those of the Mons, Shans, Karens, Kachins, etc., which, in varying degrees, have left their mark on Burmese art. These now form part of the Union of Burma but, for most of her history, some of them such as Arakan were independent or semi-independent. Until the art of each of these has been studied separately, and the results are brought together, it will remain difficult to gain a true understanding of the art of Burma as a whole. The aim of this booklet, therefore, is not to provide a survey of Burmese art but merely to give a short introduction to the subject, illustrated by objects from the Museum's Burmese collections.

The captions are divided into two parts. The first gives a short description followed by the dimensions (height given before width) and the Museum's reference number. The second section gives further information, including in some cases material relating to the cultural context of the object shown in the illustration.

The Burmese words are Romanized according to the system given on page 67 (*conventional transcription with accented tones*) of John Okell's *A Guide to the Romanization of Burmese*, London, Royal Asiatic Society, 1971.

I Shrine, containing a figure of the Buddha Shakyamuni (see pl. 2), with attendant figures and receptacles. Carved and gilt wood inlaid with semi-precious stones, coloured glass and pieces of mirror. About 1850. H. 285·7cm. (112$\frac{1}{2}$in.) W. 185·4cm. (73in.). I.S.11–1969

On each side are containers in the form of *hamsas* (see pl. 29) and round the base of the shrine are figures of lions (*chin-thei*) placed in niches. The lower part of the platform on which the shrine rests is in the form of clouds supported on *garudas*. On each side of this area are figures of Buddha's two chief disciples, Sariputta and Moggallana, on couches. In front of the shrine are bowls for offerings and vases for flower offerings (see also pl. 6), receptacles for special offerings in the form of *thupas* (*daùng-baung-kalat*) (see pl. 5), and a box (*kamawa thit-ta*) containing texts (*kamawas*), see pl. 44.

This form of Buddha shrine in Burma can be traced to sculpture belonging to the pre-Pagan period, possibly the seventh century, which shows figures of the Buddha seated on a double lotus throne in an *aedicule* formed by columns and a pediment similar to those found on doorways in Burmese architecture. By the Pagan period it had also become conventional to represent the Buddha attended by his two chief disciples and this has been continued in painting and in small sculptures such as bronzes.

There is a striking similarity between this and other shrines and the thrones of the Burmese kings, such as the only remaining royal throne to have survived. This is the Lion Throne formerly in the Hlut-taw of the Mandalay palace, in which the king evidently sat in a doorway formed by columns and a pediment supported by a waisted and stepped plinth. Much of the symbolism represented by the figures included in the carving round the shrine and the umbrellas is also probably the same as the symbolism surrounding the royal throne. An additional similarity between this shrine and the Lion Throne, which may suggest that it was made for royalty, is the existence of lions in niches round the base. This would tend to support the evidence suggested by the figures on the *thupa* receptacle (see pl. 5), and the verbal evidence given to the original owner that the shrine came from within the compound of the royal palace at Mandalay. It is by no means certain, however, that this was the case.

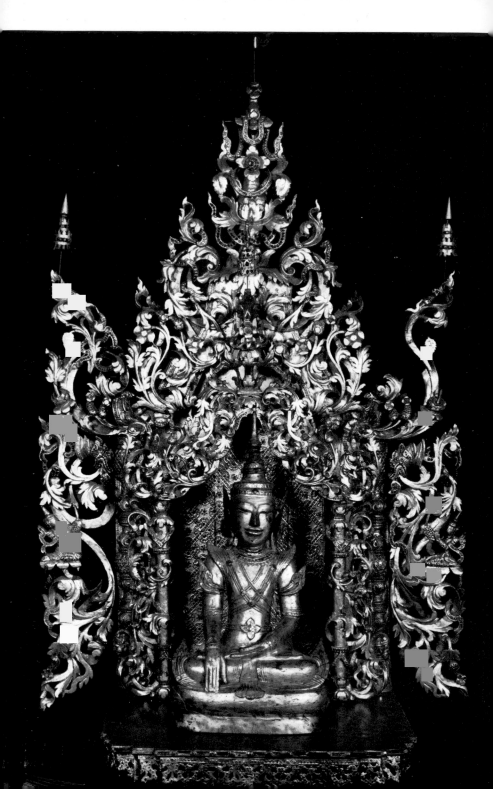

2 The Buddha Shakyamuni dressed in royal robes. Upper part of the shrine shown in pl. 1. Some of the reasons for the anomalous appearance of the Buddha dressed in this way are given in the caption to pl. 12. Although in other countries in South-east Asia, such as Cambodia, the monarch was also regarded as a deity if not in his present life then after his death, this concept was never explicitly accepted in Burma. By some sections of the Burmese community, however, it was regarded as a fact and this was the impression which was received by some of the early foreign visitors. This was partly the result of the similarity in design between royal thrones and shrines for Buddha figures. Both king and Buddha sat in a niche resembling a doorway, surrounded by elaborately carved and gilt woodwork. Each throne and shrine was raised well above floor level by a characteristically shaped plinth. Although no thrones have survived from the Pagan period, there is a possibility that they were based (either at that time or later) on representations of the Buddha seated on similar thrones within similar niches found in sculpture which belongs to the Pagan period or earlier. Thus the two ideas which stopped short of being taken to their logical conclusion, that of the Buddha who had renounced worldly possessions being regarded as a king, and that of a king being regarded as a god, tended to converge in Burmese art and theories of kingship.

The intricate scrollwork and foliage which decorates much of this part of the shrine is of an exceptionally high standard even for Burmese wood-carvers, whose technical skill seems to be unsurpassed (see pls. 42 and 43). It makes a fitting context for the worship of the Buddha figure, to which the form and arrangement of the various parts of the shrine are intended to direct the attention of the worshipper.

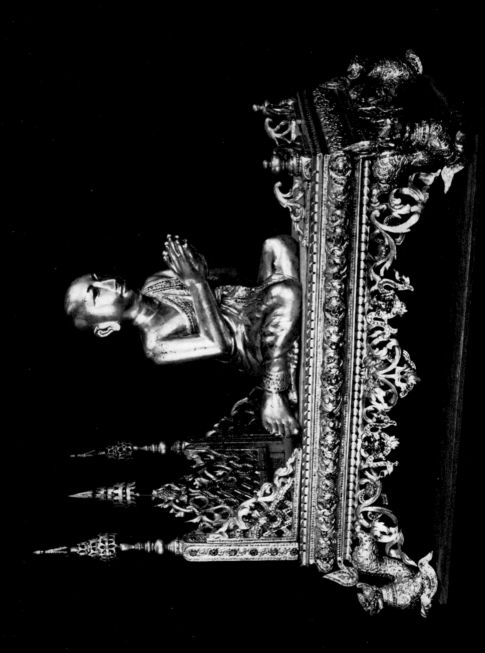

3 Moggallana, seated on a couch in a devotional attitude towards the Buddha. The figure of lacquered and gilt wood; the couch also of wood and thin metal sheet, lacquered and gilt and set with small pieces of mirror and coloured glass. About 1850. Figure 36·7cm. (14½in.), 34·3cm. (13½in.). Couch 62·2cm. (24½in.), 77·4cm. (30½in.). I.S.11(21 & 23)–1969

These are placed on the left-hand side of the shrine shown in pl. 1. Moggallana was one of Buddha's chief disciples, being second only to Sariputta (who sits on the right-hand side of the shrine); both were said to have been born on the same day and to have been childhood friends. Although they had wealthy parents, they both took up the wandering life until they met the Buddha and were ordained by him. Shortly after this he appointed them his chief disciples. Moggallana was particularly skilful in the exercise of supernatural powers and was sometimes called upon to perform magical feats by the Buddha himself. Moggallana was also second only to Sariputta in wisdom, and both were entrusted by the Buddha to keep the doctrine pure.

Moggallana was subsequently murdered at the instigation of the members of a rival sect. His ashes were probably first buried under a *thupa* (see pl. 5) erected according to the Buddha's directions at the entrance to the Jetavana monastery near Sravasti (modern Sahet Mahet, Oudh). Later they were transferred to a *thupa* at Satdhara, near Sanchi, where they were excavated and brought to England. They were placed on loan to the Victoria and Albert Museum and eventually acquired by the Museum. They were returned to India in 1948.

The group of three figures comprising the Buddha Shakyamuni in the centre, with Mogallana on his left and Sariputta on his right has a long history in Burmese art. They are shown on terracotta devotional plaques (similar to the one illustrated in pl. 24) belonging to the early 12th century A.D. which have been excavated at Pagan. It is possible that this grouping is the Theravada equivalent of the Mahayana triad consisting of the Buddha in the central position with a Bodhisattva on each side.

The couch is similar to those on which, in Burmese sculpture, a figure of the Buddha is shown reclining as he enters into Parinibbana, and also to those which are sometimes given to Burmese monasteries as a pious donation. The use of lions to support each corner of the couch in the illustration seems to have become popular in the early nineteenth century, and can also be seen supporting the silver centrepiece illustrated in pl. 33.

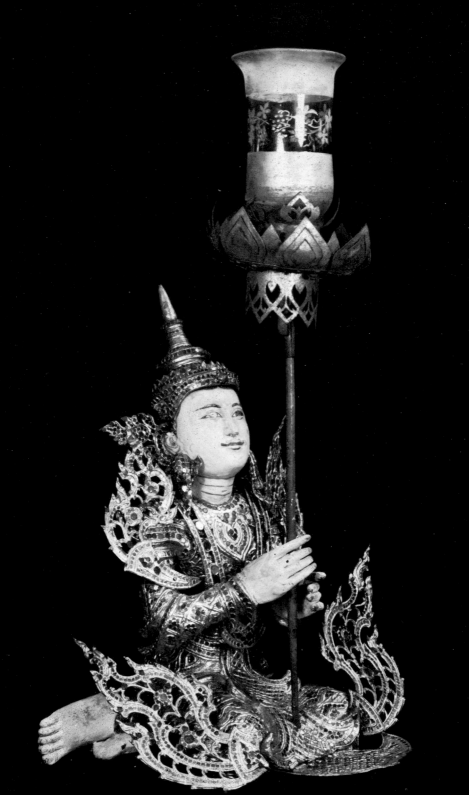

4 Figure of Brahma or Sakka, forming part of the shrine group shown in pl. 1. Carved and painted wood, and sheet metal, lacquered and set with pieces of mirror and coloured glass; the lamp of painted wood and metal with the glass candle-shade having an etched design. About 1850. H. 64·7 cm. (25 ¹₂ in.). I.S. 11 (18a)–1969

The identification of this figure is somewhat uncertain, since there seems to be no conventional arrangement of figures belonging to shrines. Taking the close connexion between the form of shrines and royal thrones there is, however, enough convention (amounting almost to a rule) for the inclusion of both Brahma and Sakka in the symbolism of thrones. Sakka appears twice, at the top of the pediment and on the right-hand door; Brahma is given a place of honour on the left-hand door. They were both Hindu gods who appear in Buddhist texts, so that there is no anomaly in their appearance in the context of a shrine dedicated to the worship of Buddha. There do not appear to be any iconographical rules for the portrayal of either of these figures in Burmese art. It is not possible, therefore, to identify from its appearance which of the two the figure in the illustration is intended to represent. However, to judge from the relative importance of Brahma and Sakka in the scriptures it is more likely to be the last named. According to Burmese tradition whenever anything of importance was about to happen on earth Sakka's throne (*pandukambala*) becomes uncomfortable. This prompts him to descend so as to witness the incident and offer advice. Thus he was present at all the important events of the Buddha's life from his birth to his entry into Nibbana. At Kushinara, moreover, the Buddha granted his request to be allowed to stand guard over Buddhism, to punish the wicked, and reward the faithful.

Another explanation for the presence of this figure within the shrine group may be that he is simply an attendant Nat who has been given the privilege of holding a lamp so that the worshipper may more easily see the face of the Buddha. Perhaps the lamp is a symbol of the Buddha's teaching and is intended to remind the faithful to 'be a lamp unto yourselves'.

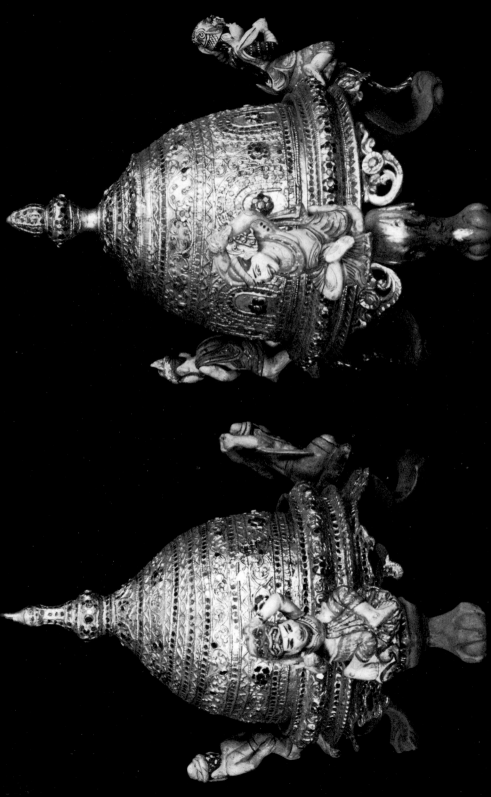

5 Two Receptacles (*daùng-baung-kalat*), forming part of the shrine group shown in pl. 1. Wood lacquered and painted and set with pieces of mirror and coloured glass. About 1850. H. 33·7 cm. (13¹₄ in.). I.S.11(16 & 17)–1969

It is probable that these receptacles were used to hold special offerings, perhaps associated with alchemy, made by worshippers to the shrine. In shape they resemble a *thupa* or relic mound. These mounds belong to the pre-Buddhist period in India (and elsewhere), when they were used to mark burial sites. After the Mahaparinibbana of the Buddha his relics were divided up and placed in eight *thupas*. Later still they were erected over the relics of eminent Buddhist teachers, etc., or of people closely connected with the Buddha himself, such as those of Sariputta and Moggallana (see pl. 3). Perhaps the most famous *thupas* of early Indian Buddhism are those of Bharhut and Sanchi. As an architectural form the *thupa* was taken up in Burma (as well as in other Buddhist countries), where, together with the preaching hall (*cetiya*) and monk's quarters (*vihara*), it became part of the basic group of buildings forming a monastery. Perhaps the best known examples of the many thousands of *thupas* in Burma are the Shwei-zì-gon at Pagan (early twelfth century) and the Shwei-dagon in Rangoon (mainly fifteenth century).

The three figures attached to each receptacle in the illustration can be identified by their dress as alchemists (*zaw-gyis*). Alchemy was as popular in Burma as it was in Europe, although its main purpose was slightly different. As well as being sought after for its power to transmute base metals and as a universal remedy, the philosopher's stone was also thought to give longevity if carried in the mouth. This appealed to Buddhists who thereby hoped to remain on earth until the coming of the next Buddha, Metteyya. The existence of *zaw-gyis* on these receptacles is highly unconventional and it is difficult to give a precise explanation for their presence. It is possible that they were included in the group as a result of King Pagan Mìn's interest in alchemy and that, therefore, at some time this group may have been associated with him.

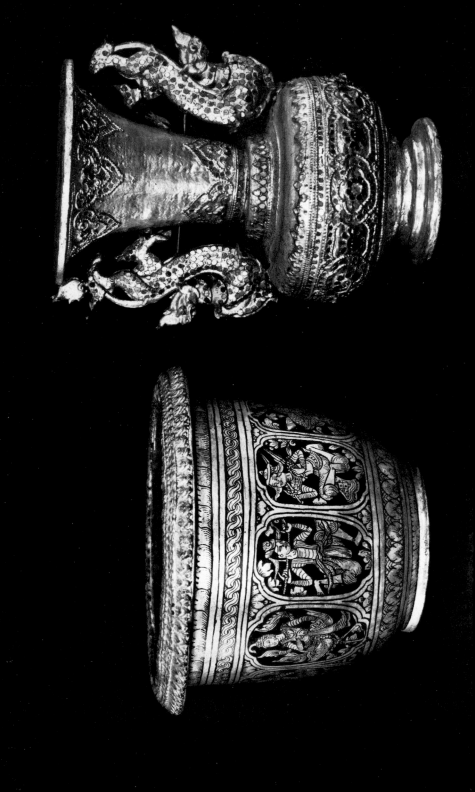

6 Vase and Bowl, of wood; the vase of gilt lacquer moulded in
relief and set with pieces of mirror and coloured glass, the bowl
with moulded gilt lacquer decoration round the rim and black and
gold lacquer decoration round the sides. About 1850. Vase H.
24·8 cm. (9$\frac{3}{4}$ in.). Bowl H. 19 cm. (7$\frac{1}{2}$ in.). I.S.11 (28 & 30)–1969

With another similar bowl and vase, forming a pair of each, these
belong to the shrine group shown in pl. 1.

Although it is not obligatory, a worshipper at a shrine usually
makes some offering to the image of the Buddha and even the poor-
est will try and bring something to place in front of it, such as a
few flowers, a candle or some rice, especially if he has a more than
usually strong reason for wanting his prayers to be heard. In the
normal way, these offerings help to increase his spiritual prestige.
They form as much part of the ritual of worship as, perhaps, a small
gift of flowers may form part of an English social visit. Receptacles,
such as these and the ones shown in pl. 5, are therefore provided in
which offerings are placed. Here, the vases are obviously for flower
offerings, and the bowls for fruit or any other food which may be
offered.

A large and important public shrine, or image which is in worship,
may have many containers in front of it; these may be not only of
lacquered wood but also of porcelain, earthenware, brass or
basketwork.

The hybrid mythological figures forming the handles to the vase
are somewhat unusual in Burmese art. They appear to be similar to
the *tò-nayà* which are used to decorate the top of some Burmese
weights.

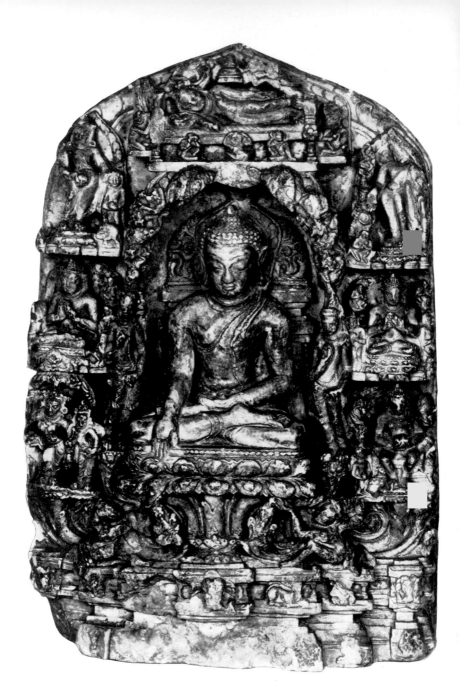

7 Eight Scenes from the Life of the Buddha, Plaque of carved, red-stained steatite (Burm. *an-dagu*). Probably 12th or 13th century. H. 8·5 cm. (3 ⅛ in.). I.M.378–1914

The scenes shown are, clockwise, beginning from the bottom left-hand corner: the Nativity, in which the Buddha was born from his mother's right-hand side while she stood holding a branch of a *sal* tree; the First Sermon, which the Buddha gave in the Deer Park; the encounter with the Nalagiri elephant, which the Buddha prevented from destroying him by overcoming it with love; the Mahaparinibbana; the Descent from the Tavatimsa heaven (see pl. 14); the Twin Miracles, in which flames arise from the Buddha's shoulders and water pours from his feet while at the same time a vast number of images of himself appear all over the sky; and at the bottom right, the Parileyyaka episode, in which the monkey offers the Buddha the gift of a honeycomb; centre, enlightenment.

The origin of illustrating the main scenes of Buddha's life in a single piece of sculpture can be traced to the art of Gandhara, in which examples showing four scenes may be found. Five scenes were shown in the art of India at Mathura and eight scenes in sculpture of the Pala period. It is to this style that the plaque shown in the illustration opposite is most closely related. The similarity is such that it is not certain beyond doubt that the plaques attributed to Burma are positively Burmese and not Indian. However, the larger proportion of them was found in Burma, and the steatite of which they are carved is unlike the stone of most of the sculpture of the Pala period. On balance, therefore, the likelihood is that they probably come from Burma but were, perhaps, carved by Indian sculptors or by sculptors trained to work in the Pala style. That such a relationship may have existed between the two areas is suggested by the sculpture and painting which is found in some of the Pagan temples. Possibly an additional indication of Burmese provenance may be the somewhat Burmese treatment of the figures, in particular the facial features.

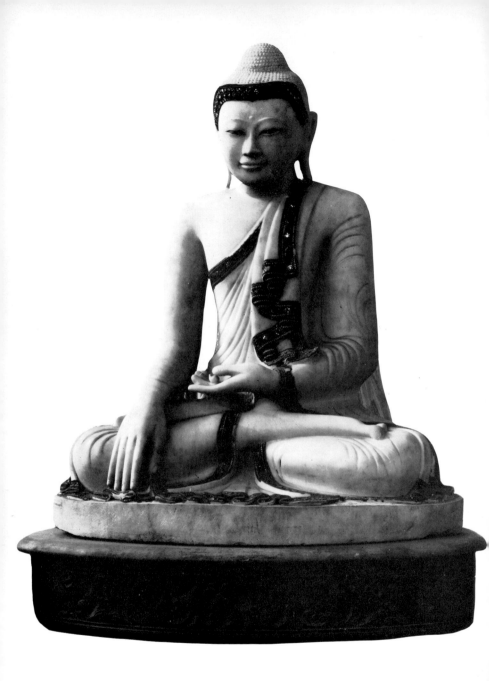

8 Figure of the Buddha Shakyamuni. Marble partly lacquered and set with pieces of coloured glass; the base is of carved teak. Probably from Mandalay; mid 19th century. H. 175·5 cm. (69 in.). I.M. 239–1923

The figure in this illustration represents what is, possibly, the most characteristic form of Burmese religious sculpture. The posture in which the Buddha is seated is usually known as the 'earth-witness' attitude. This represents the moment when Buddha was seated in meditation under the Bodhi tree during the night before he achieved enlightenment. When he was asked by Mara to name anyone who would give evidence that he had given alms, the Buddha moved his right hand and touched the earth and said that the earth would bear witness that, in a previous existence in the form of Vessantara, he had given alms to such an extent as to cause the earth to quake. Immediately before this incident his right hand was folded in his lap in precisely the same way as his left; here he has moved it in order to touch the earth in front of him in the gesture of calling the earth to witness (*bhumisparsha mudra*). This is one of the three most popular ways of showing the Buddha in Burmese art; the other two represent him standing (see pl. 16) and at the moment of his Mahaparinibbana (see pl. 7).

The marble of which this image is made comes from two main quarries, one in the Sagyin hills to the north of Mandalay and the other near Kyauk-hse, south of Mandalay. It was in use for religious sculpture at least as early as the seventeenth century and seems to have increased in popularity during the late eighteenth and nineteenth century; it is still being used for religious figure-sculpture today. The early marble images were partly painted, and sometimes gilt; details, such as the small curls of the Buddha's hair, were also added in lacquer. Here, the curls have been cut into the stone but a jewelled fillet round the hairline, and decorative borders to the Buddha's robe have been rendered by lacquer inset with pieces of coloured mirror glass.

A broad band, corresponding to the fillet on this image, seems to have become a popular motif on Burmese images of the Buddha towards the end of the eighteenth, or in the early part of the nineteenth century (see pl. 15). The reasons for this development are not yet entirely clear. It is possible that the motif was introduced from Thailand, where it is found in a slightly different form on bronzes showing Khmer characteristics belonging to the early Ayudhya period, which is associated with the name of Prince U Tong.

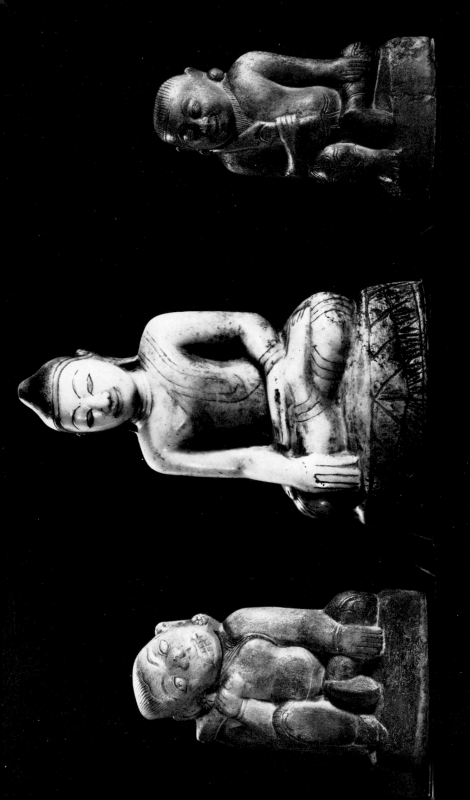

9 The Buddha with two attendant *balù* figures. Marble. From Mayong, N. Shan states; probably 19th century. H. (of Buddha figure) 37·5 cm. (14 $^3/_4$ in.). I.S.53–55–1968

Given to the Museum by Miss T. Clay

The marble from which these images are made is similar to, and probably from the same source as, those shown in pls. 8 and 10.

Balùs are related to the *yakkhas*, which are frequently mentioned in ancient Indian texts. *Yakkhas* were minor deities which, in turn, were related to the popular deities who inhabited trees, rivers and the earth and formed the object of worship by village people. At first they were regarded as benevolent beings who were originally adopted into the sophisticated religions such as Buddhism with a great deal of respect. Thus not only Sakka but also the Buddha Shakyamuni could be described poetically as *yakkhas*. At a later stage, however, the group of peaceful deities became enlarged to include others who were fierce and malevolent. It is usually in this form that they appear as *balùs* in Burmese art, where their function is usually described as that of ogres. Their skin is often shown as having a blue colour, and they have a fierce expression which is emphasized by their long eye-teeth. They can appear almost naked, as in the illustration opposite, or they may wear elaborate clothes and headdresses and carry swords with elongated lozenge-shaped blades. In the hierarchy which lives on the slopes of Mount Meru they rank below the level of the Four Great Kings. Together with Nats, ghosts and other hostile spirits *balùs* are liable to bring trouble and misfortune, which, however, can sometimes be prevented from occurring. Before ceremonial meals, such as those given to Nats, a *balù*'s face is painted on the side of an earthenware pot which is then broken to pieces before the feast begins.

Under these circumstances it is difficult to account for the relationship between these two *balùs* in the illustration and the Buddha figure with which they evidently belonged. It is possible that they were *balùs* who were closely associated with some local activity and were worshipped in conjunction with the Buddha or that, as benevolent deities, they were placed next to him in order to protect him from the enemies of Buddhism.

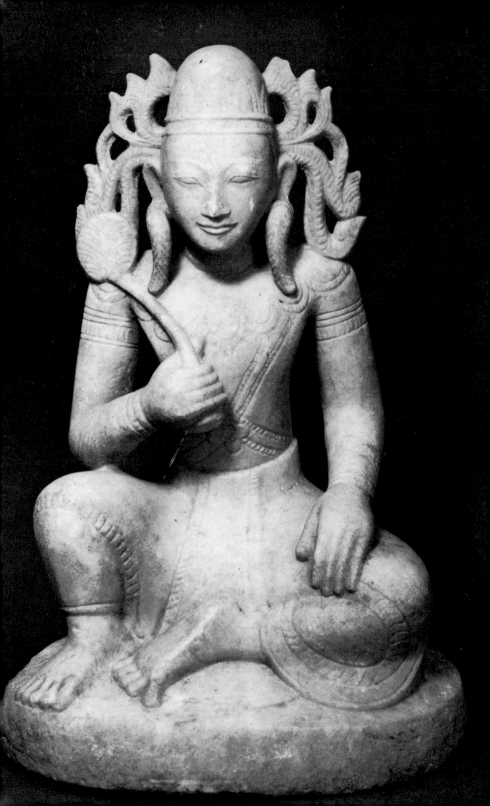

10 Lokanatha. Stone similar to marble. Possibly 17th or 18th century A.D. H. 61·5 cm. (24³₄ in.). I.S.16–1970

The crown worn by this figure is similar to those worn by some crowned Buddhas, such as that shown in pl. 12; the ear ornaments of flowers (*karnapuras*) as well as the jewellery and robes are also associated with royal attire. He sits in the posture of royal ease (*rajalilasana*) and holds a lotus in his right hand. In Burmese art Lokanatha is shown perhaps more conventionally, and following Indian examples, as sitting in *lalitasana* with the right foot below the level of the lotus throne and with his right hand in the gift-bestowing gesture (*varada mudra*) and his left hand either holding the stem of a lotus or touching his left shin. To some extent therefore the identification of this figure is uncertain.

Lokanatha is a form of Avalokiteshvara, whose duty it is to watch over the world during the period between the Mahaparinibbana of the Buddha Shakyamuni and the coming of the next Buddha, Metteyya. Figures of Lokanatha begin to appear in Burmese art as early as the seventh century A.D. on votive tablets (see pl. 24) found at Shri Kshetra and later at other sites including Pegu and Pagan. After about the eleventh century Lokanatha images, which were probably never particularly popular, seem to have gone out of fashion, although tradition was maintained until the nineteenth century that figures of Lokanatha should be included in the decoration of royal thrones (see pl. 1). Several other figures similar in style to the one shown in the plate opposite and therefore probably of about the same date are in existence. Their positive identification with Lokanatha and the tracing of the development of this figure from those belonging to the seventh–twelfth centuries is an apt illustration of the kind of problem which faces students of Burmese art.

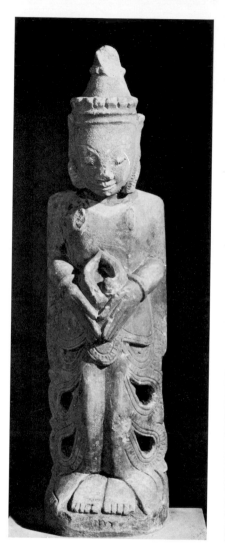 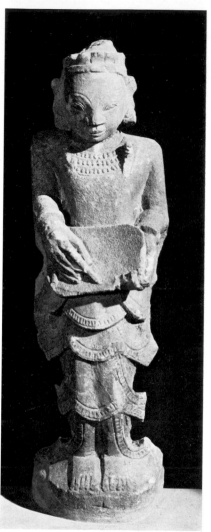

11 **Two Figures,** of Sakka (*left*) and Matali (*right*). Sandstone. From Yahkaing-gyì, near Kyauk-hse; possibly 17th century. (*left*) 73·7cm. (29in.), 19cm. (7$\frac{1}{2}$in.). (*right*) 67·3cm. (26$\frac{1}{2}$in.), 19cm. (7$\frac{1}{2}$in.). I.S.78 & 79–1954

These two figures were identified by the tradition of the locality in which they were found. It relates to the activities of the Four Great Kings, one of whom dwells in each of the four quarters. In addition to guarding Buddhism they undertake, each month, to make a report on the activities of the human inhabitants of the earth. According to some texts, such as the *Mahagovindasutta*, the king of the southern quarter hands the report of the good deeds which have been performed within his dominion to Pancasikha, who takes it to Matali, who then hands it to Sakka himself. Here, Matali is shown with a book and pen as if he were compiling the record instead of merely acting as a go-between. The object held in Sakka's hands has not been positively identified.

Kyauk-hse is one of the two most important places at which the marble used for image sculpture is quarried (see pl. 8). However, the sandstone of which these images are made is somewhat unusual for sculpture, as it has a limited distribution in Burma, being found mainly in the region of Toung-ngu. This would suggest that the two images shown in the illustration originally came from further south.

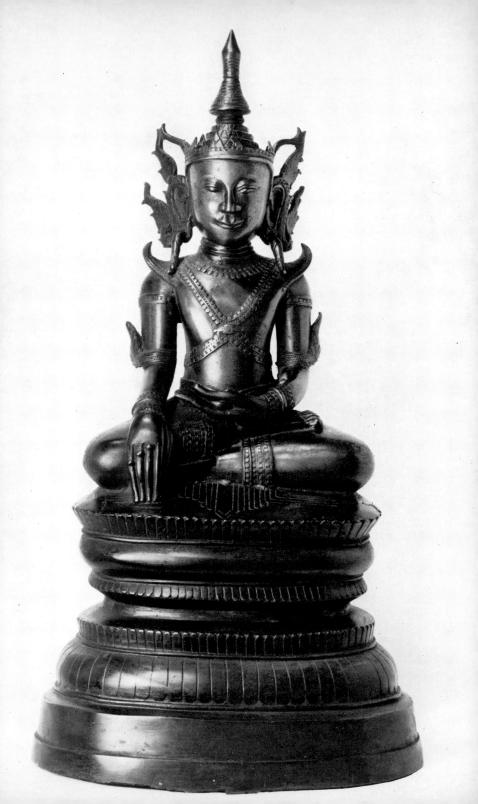

12 The Buddha as the Subduer of Jambhupati. Bronze. From the Myó-thit (Magweì) area, Upper Burma; probably 18th century. H. 45·7 cm. (18 in.). I.S.2–1960

This figure wears the crown, jewellery and robes which are associated with royalty (see also pls. 2 and 16). The bands, which form a cross over the chest, are similar to those worn by later Burmese kings. Figures of the Buddha shown in this way are in sharp contrast to the dress which he is described as wearing in the Pali texts, which were the simple garments of a monk. However, it is almost certain that Buddha figures represented as wearing royal robes in Burmese sculpture, as well as in that of other countries in Southeast Asia, were originally based on similar figures found in Indian art belonging to the Pala period (about A.D. 750–1150). Crowned Buddha images of about this date or a little later have been found in Burma at Shri Kshetra, Pagan, Pegu and other sites. They seem to have increased in popularity towards the end of the 18th century.

It is difficult to establish precisely the reasons for showing the Buddha in the dress of a king, which appears to contradict both his teaching and his own life as a monk. However, there has probably always been a substratum of thought in India, particularly amongst less sophisticated people, which links the Buddha and his early life as the son of a wealthy ruler with the idea of a Universal Monarch (*Chakravartin*). In Burma this is perhaps suggested by the name Rajadhiraja (King of Kings) which is sometimes given to crowned Buddha images. Moreover, early Pali commentaries describe how the Buddha sometimes took on the form of a king in order to preach to kings and their courts. It is probably as a result of these and similar ideas that crowned Buddha images were first made in India and Burma. Towards the end of the eighteenth century in Burma another explanation became formalized in writing, probably in continuation of an older oral tradition. This describes how a powerful king named Jambhupati threatened to annex the dominion of king Bimbisara of Rajagaha. Bimbisara called on the Buddha for aid and in response he sent Sakka to bring Jambhupati before him for admonition. In order to impress Jambhupati with his power he caused a magnificent palace to be built and took his seat on a jewelled throne under a white umbrella. When Jambhupati saw all this he acknowledged the Buddha and became a monk. Although the wearing of a crown and royal robes by the Buddha is implied in the text rather than described explicitly, the name Jambhupati, which is given to crowned Buddha figures in Burma, leaves no doubt as to its close connexion with this text.

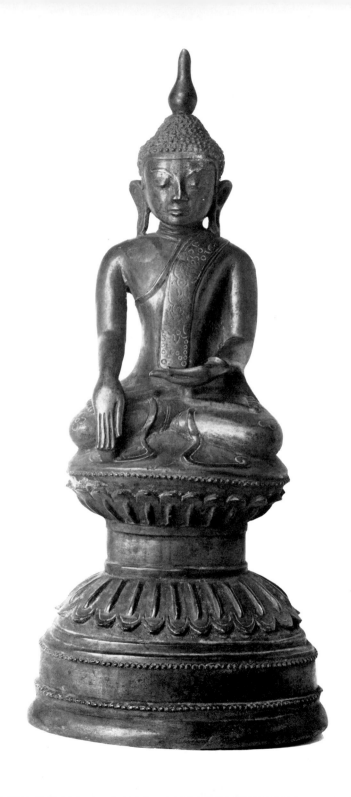

13 The Buddha Shakyamuni. Bronze. Probably 17th century. 50·8cm. (20in.), 20·3cm. (8in.). I.M.61–1912

Many of the features of this image can be seen in other illustrations of Buddhas in this booklet, such as those shown in pls. 7, 8, 9, 17 and 24.

Although the Buddha never sat for his portrait, it is traditionally believed that an image of him was made out of sandalwood, from memory, while he was away on a visit to the Tavatimsa heaven (see pl. 14). However, it is regarded as being most unlikely that any kind of representation was made of him during his lifetime, or even soon after his Mahaparinibbana. The texts which describe the sandalwood image were probably written long after this event, since in the earliest Buddhist sculpture in India, such as that at Bharhut, Sanchi and Amaravati, the Buddha's presence is indicated aniconically by symbols which include a wheel, a turban or an umbrella. Within a comparatively short time after images of him first began to be made (about the first or second century A.D.) the ways of representing him were restricted to a small number of conventional types. These included the one shown in the illustration which shows the Buddha at a moment during the night which preceded his Enlightenment (see pl. 8). The elongated, vase-shaped object on the top of his head (sometimes described as a jewel, and sometimes as a lotus bud) seems to be a particularly Burmese trait which is most marked during the seventeenth century (see pls. 2, 12, 16 and 17). The Buddha wears the simple robes of a monk (which here, however, have received some decoration) that leave the right shoulder bare. He sits on a double lotus throne which is sharply waisted in the middle. This, too, seems to be a characteristically Burmese trait which was also applied to other forms of Buddha's thrones, such as those shown in pls. 1 and 17. Another idiosyncrasy, possibly indicating seventeenth century date, is the way in which the left hand is supported from underneath by a short column. This appears to be related to a similar practice in marble sculpture. While it is possible to see why this was thought to be necessary in stone sculpture, it is difficult to account for its use on a bronze casting.

In a few, rare, cases in Burmese sculpture, the left hand is shown in the earth-witness position instead of the right hand.

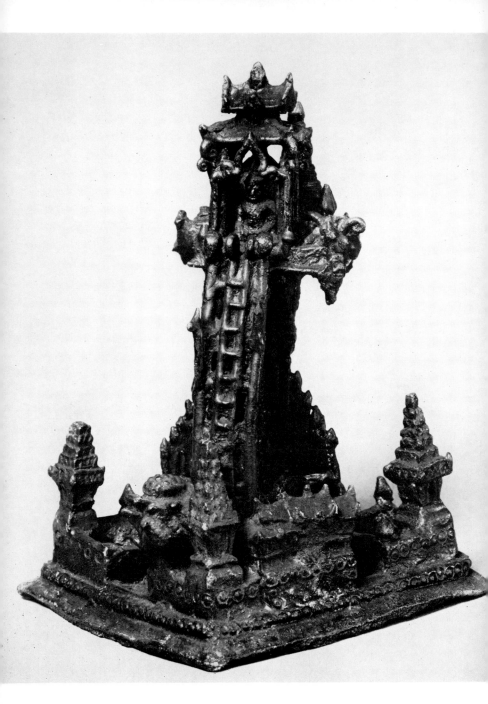

14 Buddha in the Tavatimsa Heaven. Bronze. From Moulmein; date uncertain, but possibly first half of the 19th century. 17cm. (6³⁄₈ in.), 11cm. (4³⁄₈ in.). 226–1865

This is an example of the simple village art of which there is a great deal in Burma. It stands between the more sophisticated examples, such as those shown in pls. 12, 13 and 18, and what could more properly be described as folk art belonging to the less advanced ethnic groups which inhabit Burma's remoter areas. Another example of this group is illustrated in pl. 50.

Although somewhat crude in execution, this bronze corresponds tolerably well with descriptions of the Tavatimsa heaven as described in the Pali texts, particularly the Jataka stories (see pls. 21, 22, 46, 48 and 49). The Tavatimsa is the second of the six Buddhist heavens and stands at the top of Mount Meru; Sakka is its king (see pls. 4 and 11). The Buddha spent three months in the Tavatimsa preaching the Abhidhamma to his mother. He sat on Sakka's throne in the Sudhamma meeting hall (shown at the top of this bronze) and also preached from the foot of the Paricchatta tree (which is one of the characteristic features of the Tavatimsa and distinguishes it from the other heavens), the flower of which has unusual properties. Its colour can be seen fifty leagues away and its perfume travels one hundred leagues; when it is open it shines like the morning sun while the wind blows off the petals and scatters them on Sakka's throne and the seats of the other gods. A bloom of this tree is shown to the right of the building in which Buddha is seated. Behind, and to the right of this building, can be seen the Chulamanicetiya (*thupa*, see pl. 5) in which was placed the hair which Buddha cut off when he renounced the world, and also Buddha's eye-tooth which was put in the same *thupa* by Sakka. In front, a ladder, which was said to have been made of jewels, leads down to earth, which it reached at Sankassa (modern Sankissa). A shrine was erected at the spot where the Buddha's right foot touched the earth and it is this that is probably intended by the building shown at the bottom, right of centre, of this bronze (though this would be on the Buddha's left). The pyramid shaped buildings at each corner are probably intended to represent the four earthly continents, with Buddha's descent facing East; this suggests a reason for aligning the building, in which Buddha is seated, at the top of the ladder with the diagonal of the square, so that it could face one of the four cardinal points.

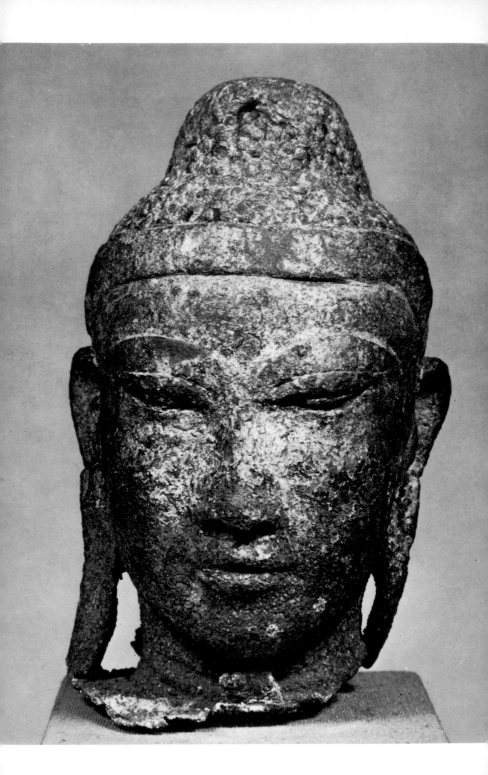

15 Head of the Buddha. Cast lead. Probably 19th century. 19·3 cm. (7⅝ in.), 11·1 cm. (4⅜ in.). I.S.41–1963

The use of lead for making images is rare in Burma, although the metal has been used for centuries as a building material. According to the Chinese T'ang Annals the Pyus were using lead for roofing their houses in about the eighth century A.D.; it is also possible that they made images of lead. The ore is found in the Shan States, where an inscription records that it was worked in A.D. 1412, but this was possibly more for the silver which is also found in the same place. These facts may provide a reason for suggesting that the head shown in the illustration might have come from the Shan States. By the early eighteenth century ore was being exported from Syriam by British traders in spite of a royal prohibition. Towards the end of the century Bò-daw-hpayà used lead to line the image vaults of his Mìn-gùn Pagoda. Its use as a substitute for bronze in sculpture was evidently an isolated experiment which was not widely followed.

The style of this head, with the wide band running across the forehead, suggests that it was made some time during the nineteenth century (see pl. 8).

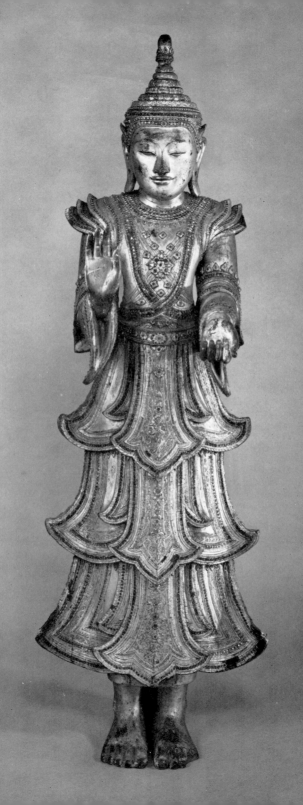

16 Standing Figure of the Buddha. Wood carved, lacquered and set with pieces of mirror glass and semi-precious stones. Probably 19th century. H. 144·8 cm. (57 in.). I.M.39–1912

The Buddha is dressed in the royal robes of the subduer of Jambhupati (see also pls. 2 and 12). His costume is also very similar to that worn by the two minor gods (*devas*) carved on the doors shown in pl. 42 and also to some forms of royal costume.

The origin of standing figures of the Buddha, and also those shown in other postures (see pl. 8), can be traced to sculpture belonging to about the second to fifth centuries A.D. from the ancient kingdom of Gandhara, which lay in what is now Pakistan and Afghanistan. Slightly later, in northern India and the Deccan, three different types of standing Buddha figure developed according to the position of the hands. In Burma these were taken up by the Pyus (who used at least one form on a terracotta plaque found at Hmawza) and the Mons, by whom they were passed on in a slightly modified form to the art of Pagan. It is the standing figures at this site, such as the four large bronze images in the Shwei-zì-gon, on which the figure in the illustration, with only slight alteration, is based. The raised right hand of the Shwei-zì-gon images (and many of the Indian ones) is in the gesture indicating blessing (*abhaya mudra*); that of the figure in the illustration indicates argument (*vitarka mudra*). The position of the left hand is also similar to some Indian images. In figures of the Buddha dressed in monk's robes he was often shown holding the corner of one of his garments in his left hand. Here, however, although the hand is still in the same position for holding the robe, it has been left empty. Perhaps the craftsman did not want to destroy the balance of the robes arranged symmetrically from the waist to the ankles.

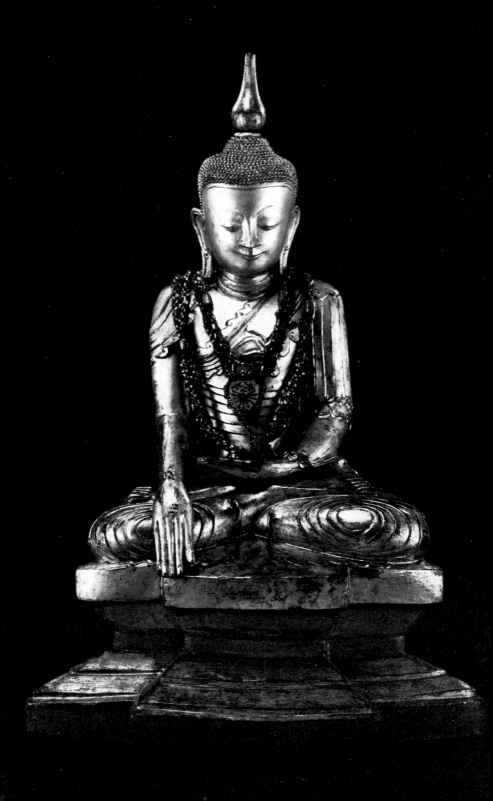

17 Figure of the Buddha Shakyamuni. Gilt dry-lacquer. Possibly 17th century. 106·7cm. (42in.), 67cm. (26$\frac{1}{2}$in.) I.S.21 & A–1970

Possibly the earliest dry-lacquer figure in Burma is that of Kyan-zit-tha, dating from the late eleventh to the early twelfth century A.D. in the A-nan-da temple, Pagan.

This image has several interesting features not only in relation to its technique but also to its style and iconography. Dry lacquer is a technique which was probably imported from China, where it was also used for making images which were usually of a fairly large size. In Burma, on the other hand, the majority of dry lacquer figures are not large. Since in these cases the one advantage which they have over stone or bronze images, that of lightness, becomes unimportant, the reasons for using this technique may be difficult to find.

The treatment of the robes is somewhat unusual in Burmese art. They are shown clinging tightly to the figure in highly stylized folds which are ridged in almost parallel lines. The representation of Buddha's robes in loose, somewhat naturalistic folds may be seen in Gandhara sculpture belonging to the second to fifth centuries A.D. These become tighter and more stylistic in the Gupta period in India and, later, in Kashmir, China and Japan. This trait, together with the 'S' curls at the edges of the robes and also the flap which covers the right shoulder make it difficult to decide precisely which part of Burma this image came from. However, the flap over the right shoulder seems to have originated in China and this idiosyncrasy may, therefore, probably be confined to the areas close to Burma's borders with China, perhaps where those of the eastern Shan states march with those of Yunnan.

Dry lacquer figures are usually hollow; they are built up with cloth soaked in lacquer on a wooden framework or a clay core which is subsequently removed. Alternatively, the cloth is pressed into a lacquer mould which has been made of a figure carved out of wood. In both cases the details are added after the main form has been made, and the surface polished and gilded.

Although larger, public, images may sometimes be given shawls of cloth as well as jewellery and ornate crowns, the placing of necklaces round the neck of Buddha figures as an act of veneration is unconventional in Burma. Those belonging to the figure in the illustration were probably made in India (perhaps Lucknow).

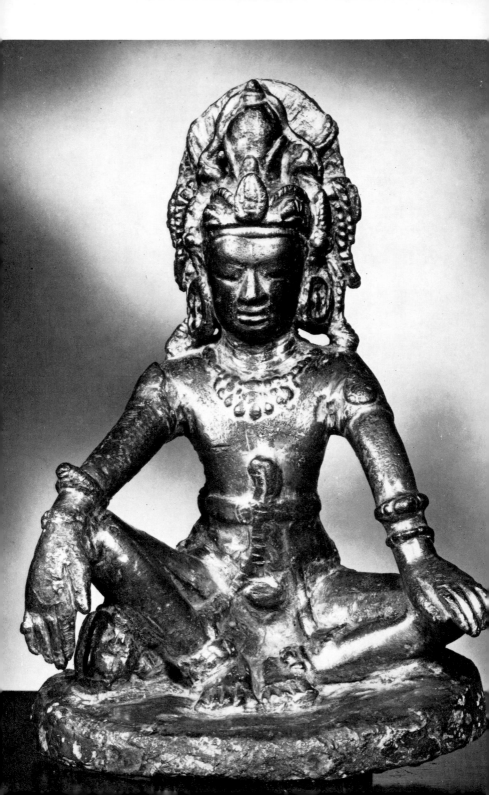

18 Metteyya. Gilt bronze. Possibly 8th or 9th century A.D.
H. 18·5cm. (7$\frac{1}{4}$in.) I.M.39–1922

This bronze was found at Pagan, where several similar figures have
been discovered, some of which carry Pyu inscriptions. One of
these mentions Metteyya, which provides some evidence for the
identification of this image. The appearance of the dome-shaped
object in the upper part of the headdress, similar to a *thupa*, which
is one of the symbols of Metteyya, may support this identification.
It could, however, have been intended to represent the chignon
which is often the conventional way of rendering the hair style
worn by Bodhisattvas. Stylistically the figure opposite is slightly
different from the other Metteyya images found at Pagan; also, un-
like them it does not have the sacred cord (*upavita*) over the left
shoulder. Although it is possible that this type of Metteyya image
originated in Shri Kshetra, examples in several temples at Pagan
suggest that they may have been made later than their Pyu
inscriptions imply, by craftsmen who still worked in the earlier
tradition. This also seems to be indicated by the rather more
Indian appearance of the figure illustrated, which, therefore, may
be as late as the tenth or eleventh century.

Metteyya is the next Buddha, who is waiting in the Tushita heaven
to come down to earth at the appropriate time. Conventionally
this is shown by the way in which he sits representing the moment
when he uncrosses his legs from the position (*dhyanasana* or
padmasana) adopted by the Buddha (see pl. 8) in order to make the
descent. Here the posture happens to be identical with that of
'royal ease' (see also pl. 10). As a Buddha-to-be he is still a Bodhi-
sattva and thus wears the headdress and jewellery of a deity of this
rank. Metteyya and Lokanatha (see also pl. 10) are the two Bodhi-
sattvas which are usually recognized by Theravada Buddhism. How-
ever, during the Pyu period (approximately early seventh to mid
ninth century A.D.) it is probable that both Mahayana and Thera-
vada, had their adherents. The figure in the illustration may there-
fore have been intended to represent some other deity such as one
of the forms of Avalokiteshvara.

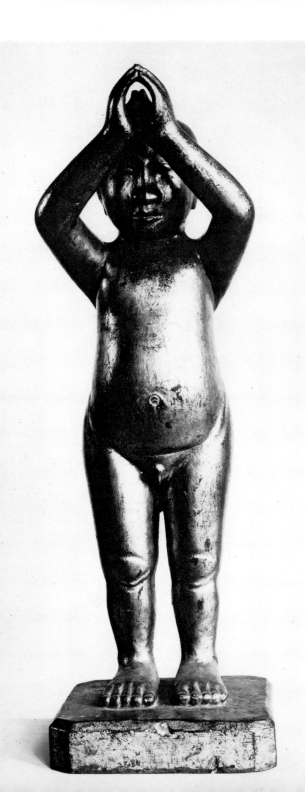

19 Figure of a Child. Carved and gilt wood. Probably second half of the 19th century. H. 60·5 cm. (23 ³₄ in.). I.S.88–1954

Burmese sculpture was almost entirely religious until about the beginning of the nineteenth century, when European influence began to have an effect. Possibly one of the more regularly produced examples of secular sculpture may have been figures of children such as the one illustrated opposite. They were made to stand in front of the king's thrones, of which there were conventionally nine in each royal palace. Each throne had eight child figures, or pages, which were regarded as symbolizing the development of the king's prestige. As they grew day by day it was believed that the king's authority and glory would also correspondingly increase. The total number of these child figures belonging to the thrones in the last royal palace at Mandalay must have been seventy-two. In addition to the one shown here another four are known to exist. Although the only royal throne to have survived belongs to the mid nineteenth century (see pl. 1), it corresponds precisely to descriptions of royal thrones written in the early nineteenth century, which, in turn, were based on late eighteenth century records. In the first account of the palace of King Bò-daw-hpayà, however, no mention is made of the presence of these figures in front of thrones. They are first mentioned in a second account made towards the end of his reign in 1816. This suggests either that their earlier omission was an oversight or that they were an innovation introduced during his reign.

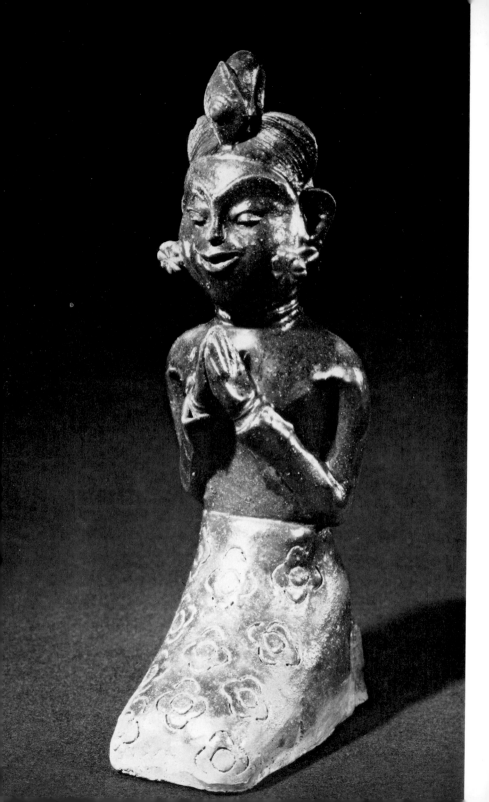

20 Female Devotee. Terracotta with dark and light brown glaze. From Prome; possibly 16th or 17th century. H. 31 cm. (12$\frac{1}{4}$ in.). I.M.38–1912

This figure probably belonged to a group (which may or may not also have been made of glazed terracotta) comprising a figure of the Buddha with his two chief disciples (see pl. 3) and two devotees, one male and one female, which are arranged on each side of the central figure. Figures of lay devotees are often of painted or lacquered wood although bronze and stone examples exist, such as those found in one of the relic chambers of the Yei-gyi-yei-nauk pagoda, Bassein, which may belong to the fifteenth or sixteenth century. These are evidently portraits and thus suggest that they were intended to represent donor figures. It is conceivable, therefore, that the figure in the illustration opposite may also have been intended as a portrait although the representation seems to be somewhat stylized. At all events it is an interesting example of Burmese modelling technique used to produce a piece of free-standing sculpture. Although modelling was used to great effect in creating the terracotta plaques which decorated the interior and exterior of pagodas and temples (see pls. 21 and 22), it was less often used for making free-standing figures such as the one in this illustration.

As in other Buddhist countries, donations for religious purposes form a considerable part of a lay person's participation in the religious life of the community in Burma. The extent to which these are made depends on the means which are available. They may be small, perhaps to provide a monk with some inexpensive object, or, at the other extreme, a person may dispose of the whole of his surplus wealth (which in the West might be called his capital and held in the form of property or shares) to finance some large project such as building, or renovating, a monastery or a pagoda. As this kind of activity is commonplace it is less surprising that donors sometimes have their association with a large donation perpetuated in the form of their own images than that this is done so comparatively seldom.

The practice of showing donor figures has a long history in Buddhist art, being found in the Gandhara sculpture of India.

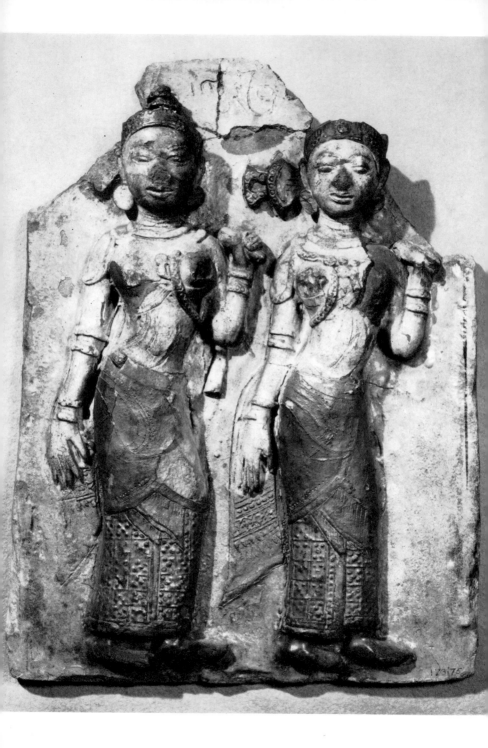

21 Two Goddesses (*devis*) from a procession celebrating Buddha's triumph over evil. Terracotta glazed with cream, green and brown. Possibly from the Ajapala pagoda, Pegu; late 15th century. 43·5 cm. (17$\frac{1}{2}$ in.), 35 cm. (14 in.). 173–1875

This plaque probably formed part of a large series illustrating Buddha's triumph which was placed round the base of the pagoda. It may have been combined with another series showing part, or all, of the Jataka stories (see pl. 22), together with a series showing the rout of Mara's army.

It is possible that illustrations from the Buddha's former lives (Jataka stories) and of incidents from his life on earth formed the subjects of the earliest Buddhist art. They might be regarded as stages in the acceptance of the idea of representing religious subjects in visual terms; first, the Jataka stories, since they did not concern the Buddha's historical existence; next, incidents from his historical life where he is represented aniconically and, lastly, as an image. These stages are not clear-cut and this development is largely conjectural. Illustrations of the Jataka stories in sculptural form for the decoration of *thupas* were used in some of the earliest Buddhist sculpture in India at Bharhut (about the second century B.C.); also at Sanchi and in Gandhara. The practice of decorating pagodas with glazed terracotta plaques modelled in relief with Jataka scenes probably began in Burma in the Mon capital of Thahton. It was brought to Pagan by the Burmese king Anirhuddha, about the middle of the eleventh century A.D., where several pagodas and temples were decorated with similar plaques. Glazed, as well as unglazed plaques, were often used in elaborate schemes such as that at the A-nan-da temple at Pagan, where the stories were related in nearly 1,500 plaques placed round the base and upper terraces. Their use here and elsewhere was probably as much educational as decorative. They acted as reminders to the faithful of the significance of the life, and former lives, of the Buddha whom they were going to worship within; that the prayers which they offered were to assist them in leading a virtuous life, which, in conjunction with their former lives and, probably, others to come, would free them from the cycle of rebirths. These plaques, therefore, performed a very similar function to the sculpture which adorned the outside of other buildings in South-east Asia such as Borobodur and Bayon as well as those in India. They can also be compared with the sculpture which is found on Christian churches and cathedrals.

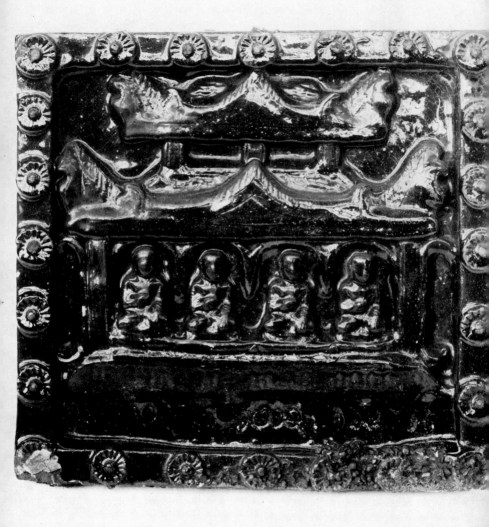

22 Wall Tile, from a temple. Brown earthenware with moulded and modelled decoration and covered with a dark brown glaze. From Mìn-gùn, near Mandalay; probably late 18th or early 19th century. 21·5cm. (8$\frac{1}{2}$in.), 22cm. (8$\frac{5}{8}$in.). 04160

The scene shown on this plaque illustrates part of a Jataka story (see pl. 21) which is mentioned in the inscription written along the bottom. This inscription is unclear but it probably refers to the Kummasapinda Jataka (No. 415), which tells how, in one of his former lives, the Buddha gave his breakfast to four paccekabuddhas (a paccekabuddha is one who has achieved enlightenment but does not proclaim it to the world) who are shown on the plaque. In return he hoped that he would not be reborn into a poor family again. This was granted and he became a king who married a queen who had also given alms in her former existence as a servant girl.

Jataka stories have a special place in Burmese life and literature; in many ways they can be said to correspond to the myths which are found in the stories of classical antiquity in Europe. The tales of the Buddha in his previous existences which they relate provide examples of moral conduct and, therefore, a pattern of situations together with their socially approved response which are available for all to follow. They are thus an unlimited source of themes for literature, art and the theatre. Children grow up knowing, more as a matter of course than as a result of study, much of the material contained in these stories. In later life they act as a code of behaviour to which people can turn, and provide a key to the understanding of visual art, secular stories and poetry, as well as plays (see pl. 48) dancing and puppet shows (see pl. 49).

According to South Indian and Sinhalese texts the usual number of Jataka stories is 547 but in Burma they are usually referred to as the 550 Jatakas. This number is shown on some buildings, such as the East and West Petleik pagodas (mid eleventh century) at Pagan but elsewhere other series are shown including the more conventional 547.

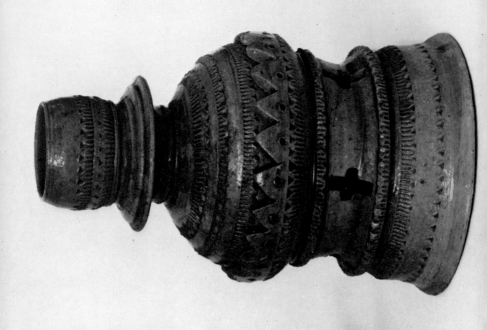
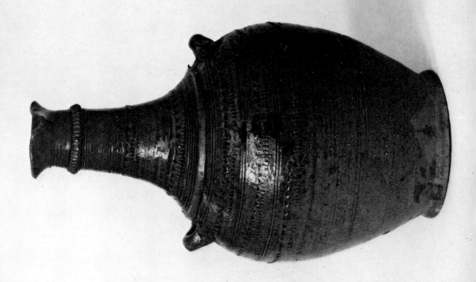

23 Two Pottery Vessels. Earthenware covered with a grey-green glaze. From Lawksawk; probably 19th century. 1. Flagon, H. 19 cm. (7$\frac{1}{2}$in.), diam. 10·2 cm. (4 in.). 2. Water cooler and stand, H. 19 cm. (7$\frac{1}{2}$in.), diam. 12 cm. (4$\frac{3}{4}$in.). I.M.137 & 138–1929

Eighth century Chinese texts (*Man-shu*) which describe the Pyu kingdom refer to wheel-made pots and glazed jars as forming part of its export trade, and also to green glazed tiles which covered the wall of the capital. However, many of the technical words used in pottery making are of Mon origin and this seems to suggest that the Mons were closely connected with the introduction of the technique. Thirteenth century records mention pottery being made at Twan-teì and this is confirmed by excavation. Also, a bee-hive-shaped kiln has been uncovered at Pagan together with ex-amples of clear glaze and opaque coloured glazes. At the Shwei-zì-gon there have survived examples of the unusual technique of glazed sandstone in the form of plaques showing Jataka stories.

There is a large number of unglazed pottery types, both built up and thrown, as well as a variety of glazed wares which are made by the ethnic sub-groups forming the Union of Burma. At Mingkung (not far from Lawksawk) the residue from burnt vegetable matter is used to make a greenish glaze. The rather brighter green of the plaques such as that shown in pl. 21 is said to have been the result of using a copper-oxide. Material for some glazes, usually galena or lead slag, was a by-product of the lead industry not only in the Northern Shan States (see pl. 15) but also in the Southern Shan States, the Amherst and Mergui districts and near Bhamo. Almost equally widespread are yellow, brown and cream glazes.

Most of the pottery clays have colours, of which yellow is one of the more common. However, as much of the clay has an iron content, it produces various shades of red when fired, ranging from pale orange to bright brick red.

Some districts specialized in producing one, or a limited number, of objects such as the area near Ava which specialized in the making of begging bowls for monks.

As well as cooking and storage vessels, tiles and decorative plaques similar to those illustrated, both glazed and unglazed, Burmese potters made elaborate flower vases (supported by animals includ-ing horses and elephants) which were covered with a brown or yellow glaze; they also modelled small pottery figures which were glazed in brown, cream and green colours.

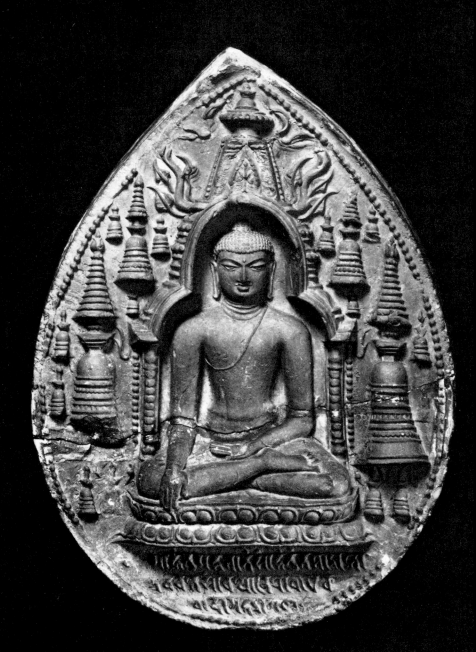

24 The Buddha Shakyamuni. Terracotta votive plaque. Probably about 12th century. 15·2cm. (6 in.), 10·4cm. (4$\frac{1}{2}$in.). I.S.658–1883

The practice of making votive tablets from mould impressions on wet clay which is then allowed to harden in the sun seems to be almost entirely confined to Buddhism and small, portable plaques made in this way have been found wherever Buddhism flourished from North-east India to China, Japan and South-east Asia. Those made in Burma are evidently based on similar plaques originating in Bengal and Bihar during the Pala period, to which they are somewhat similar. But whatever the precise link may have been, the existence of moulds found at Shri Kshetra and Pagan leaves little doubt that plaques were made at these two sites. They were cast from bronze, stone and terracotta moulds for use as private shrines, to take on a pilgrimage or purchase at the site of a pilgrimage as a memento, or simply made as an act of merit. As well as the shape shown in the illustration they were also straight at the bottom with a curved and pointed arch at the top. They are usually undecorated but may sometimes be found with gold leaf added. At the bottom of the plaques the Buddhist creed, either in Sanskrit or Pali written in Nagari script, is often stamped in relief. On the back, dedicatory inscriptions may be incised in the wet clay. In some cases this inscription is signed by the king himself and many tablets with the signature of Aniruddha (reigned about A.D. 1044–77) have been found in Burma. But it seems that anyone who could afford to do so had plaques made and signed them. The central figure is usually, as here, the Buddha Shakyamuni either seated in *dhyanasana (vajrasana)* or in the 'European' posture. Instead of being surrounded by *thupas* the Buddha may be repeated several times or accompanied by other Buddhas; exceptionally, the central figure may be the Bodhisattva Lokanatha (see pl. 10).

Below the lotus throne, in relief, is the so-called Buddhist creed in Pali:

ye dhamma hetuppabhava tesam hetum tathagato aha
tesan ca yo nirodho evamvadi mahasamano ti

'The things which arise from a cause, of these the Tathagata has stated the cause. Of these also there is a means of suppression. Such is the teaching of the great Ascetic.'

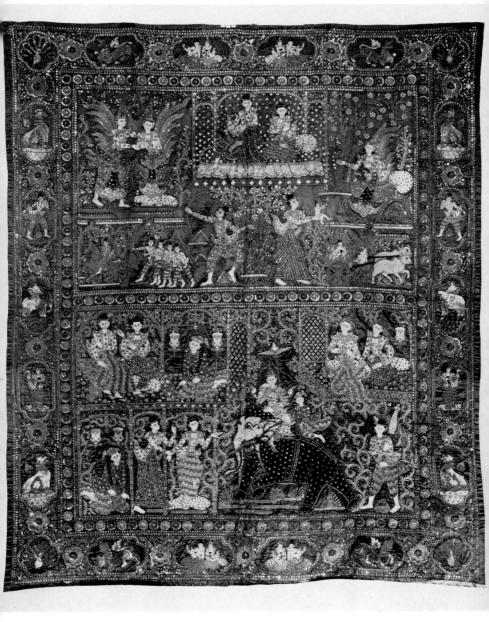

25 Embroidered Hanging (*kalaga*), showing scenes from Jataka stories. Silk embroidered with stitch-work and appliqué of black, red and pink silk on a light green ground, and with sequins. Probably 19th century. 210cm. (72in.), 170·5cm. (60in.). I.S.16–1961

This embroidery technique probably did not originate in Burma, and this is suggested by the name *kalaga* which means foreign curtain. It probably came from Europe, either directly, or by way of India. It was taken up in Burma, where the strong patterns and bright colours, often combined with sequins, appealed to both Europeans and Burmese. *Kalagas* can vary considerably in size from a few square feet to a rectangle several feet in length. As well as silk, wool and cotton were also used and, in some cases (see pl.26), details were painted in ink or water-colour. Unfortunately, some of the colours used for the dyes were extremely fugitive so that, in the strong Burmese sunlight, a large number of *kalagas* have faded. Designs include religious scenes taken from Jataka stories similar to the one in the illustration, secular themes such as pictures of the *Chìn-lòn* game or a single decorative motif, such as a peacock, alone or repeated several times. They are used in almost any situation where a decorative hanging may be appropriate; those with religious scenes can be hung up in a temple or monastery while those with a secular subject for their designs may be hung up on the wall of a room in a house, or in a garden, or be used to decorate a cart in which people might ride to take part in festivities.

During the later part of the last century Rangoon was probably the area in which most *kalagas* were produced.

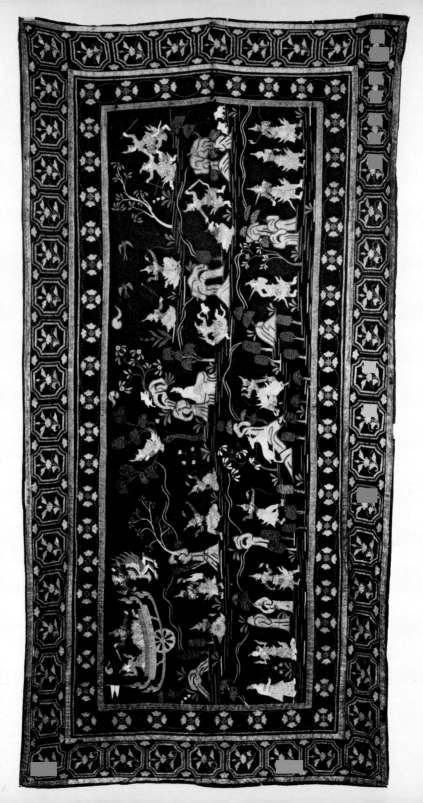

26 Embroidered Hanging (*kalaga*). Black velvet with an appliqué design, showing scenes from the *Ramayana*, of coloured felt (partly painted), sequins and tinsel. Probably late 19th century. 190·8 cm. (68 in.), 335·5 cm. (132 in.). I.S.8–1952

The embroidery shown in this illustration is, perhaps, a little more representative of this kind of Burmese technique than the one shown in the previous illustration, particularly as regards the material used. The design is bolder and more clear-cut, and is in this way similar to some forms of South Indian temple hangings.

A comparison between this and the painting shown in pl. 46 shows that there is a similar treatment of the narrative, the separate incidents distributed over the surface of the hanging without being divided off from each other. As might be expected the design also bears close similarities in other ways with painting, such as the treatment of the figures and landscape.

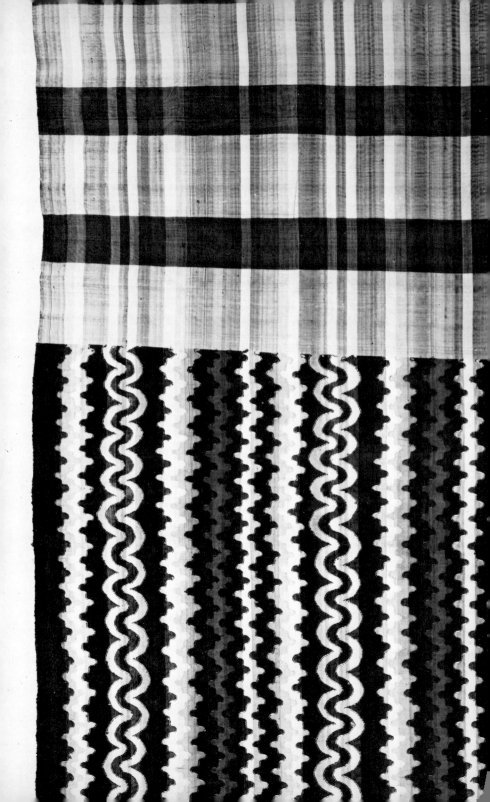

27 Part of a Lùn-Taya. Fabric for a skirt. Woven silk. 19th century. Size of area illustrated, approx. 45·5 cm. (18 in.), 31·5 cm. (12 $\frac{1}{2}$ in.). 0801 I.S.

These fabrics are stitched together to make simple skirts, *lùn-taya acheik paso* for men or *lùn-taya acheik htamein* for women. The name *lùn-taya* means hundred spool and this refers to the method of weaving the silk yarn, which is almost identical to the western tapestry technique, to form the wavy pattern at the bottom of the illustration; the striped area at the top is of ordinary simple weave, the stripes being formed by the warp and weft threads. Although this might be regarded as the traditional pattern for the garments, with changes in fashion other patterns and fabrics not only from Burma but also from Europe, India and China have become popular. The necessity of killing the silkworm as part of the process of making silk for weaving held back the development of a silk industry in Burma, where Buddhism forbade the taking of life. Silk was either imported from China or made by small communities of non-Buddhist immigrants, such as Manipuris, who settled at Prome, Ava and Amarapura. The silk yarn responds to dyeing by giving a range of delicate and muted colours. The combinations used in *lùn-tayas* are often, therefore, very effective, contrasting pale pinks, yellows and greens with deep crimson, brown and blue. The *lùn-taya* pattern shown in the illustration makes use of dark and light green, fawn, white and dark crimson.

Although they may be difficult to see in the reduced scale of the illustrations, female figures shown in pls. 25, 46 and 47 are wearing *lùn-taya acheik htamein*.

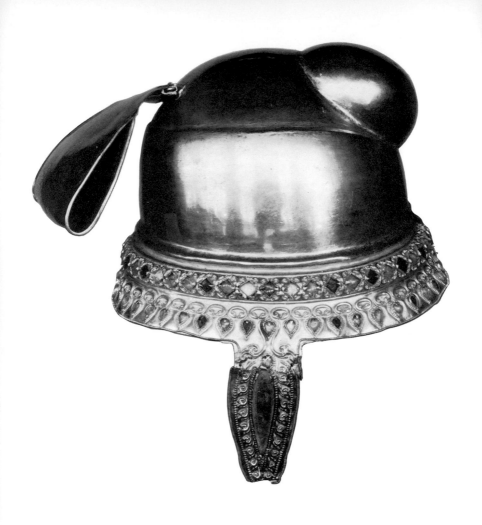

28 Headdress. Gold set with semi-precious and imitation stones. From Rangoon; possibly early 15th century. 19·7cm. (7$\frac{1}{2}$in.), 21·5cm. (8$\frac{1}{2}$in.). 02758 I.S.

This curiously shaped headdress was found, together with other objects, during excavations near the Shwei-dagon pagoda in 1855. As these excavations were not archaeological but for clearing the ground for building purposes no record was kept of precisely where they were found. Amongst the other objects were gold models of *thupas* and a gold plate bearing an inscription in Pali which appears to record the foundation of a *thupa* with its endowments and an account of other pious acts. These seem to have been made by a king, whose name, however, is not specifically mentioned. Formerly it was thought that this headdress belonged to queen Shin Sàw-bú but from the epithets by which the king is referred to and other evidence in the inscription it is possible that king Ra-za-darit (reigned A.D. 1385–1423) was responsible for causing the inscription to be written and therefore the *thupa* to be erected. Although it does not follow that the other objects found with the plate must belong to the same period, the absence of information about similarly shaped headdresses suggests that it belongs to a style which went out of existence before finding a place in oral tradition and written records that have survived until the present day.

The shape of this headdress seems to have been based on a type made from a strip of cloth tied round the head with a loop pulled out at one side rather like the *gaùng baùng* worn by men today. The bulges in the crown are asymmetrical and the leaf-shaped extension below the brim is not repeated on the other side. The small size is difficult to account for; it suggests perhaps that the headdress was either worn at the top of an elaborate chignon or by a child.

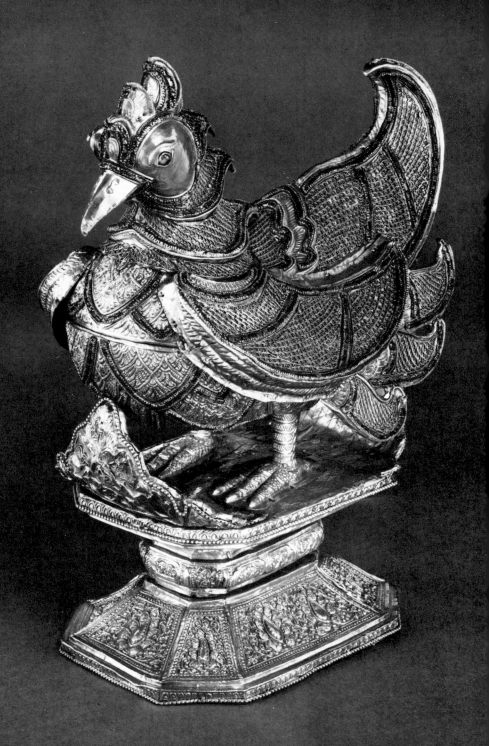

29 Betel Nut Container in the form of a sacred goose and stand (*hìn-tha kùn-ok*). Embossed gold and filigree work set with rubies and emeralds. Probably 19th century. H. 41·5 cm. (16¹⁄₄ in.). I.S.246–1964

Given to the Museum by the Government and people of Burma in generous recognition of the Victoria and Albert Museum's safe-keeping, in which the Burmese royal regalia was held from 1886 to 1964

Containers in this form are comparatively common in Burma. Usu-ally they are of lacquered wood set with pieces of coloured glass and mirror similar to those shown in pl. 1, which also gives some idea of the way in which they were used.

The sacred goose (*hamsa*) has been an important motif in Burmese art since at least the seventh century A.D. Its origins can be found in Hindu mythology, and also in Buddhism; Hsüang Tsang saw a *thupa* near Rajagriha dedicated to the sacred goose, in which form the Bodhisattva appeared in one of the Jataka stories. In Burma it was regarded as a national emblem by the Mons (see pl. 40 for the bird emblem of the last ruling dynasty), who called one of the three main divisions of their country Hamsavati (now Pegu). They con-sidered that the *hamsa* represented the ideal qualities of purity and gentleness. Of the nine royal thrones which existed in the palace at Mandalay at the middle of last century, the one belonging to the Hall of Victory was differentiated from the rest by the row of *hamsas* placed round the base. The container shown in the illus-tration formed part of the Burmese royal regalia which belonged to King Thi-bàw, who was the last representative of the Burmese monarchy. The regalia formed part of the material requisitioned as indemnity at the end of the third Burmese war in 1885. It was later placed under the custodianship of the Museum and was returned to Rangoon in 1964.

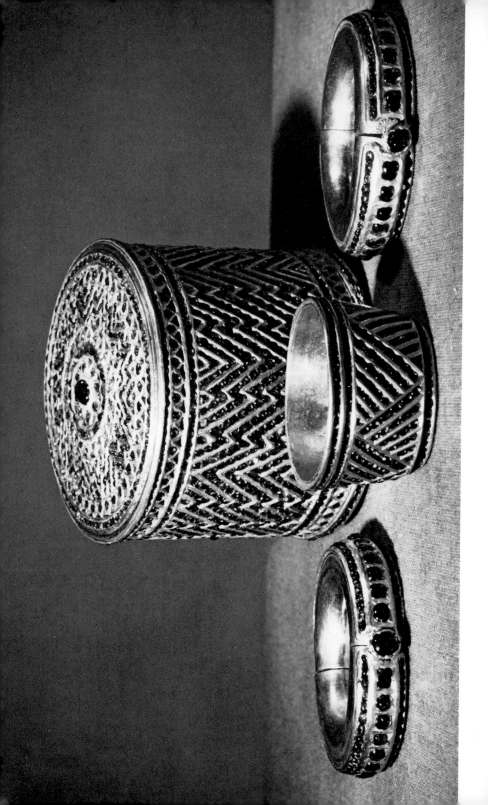

30 Box, Cup and Bracelets. Gold set with diamonds and rubies. From Ava or Mandalay; probably first half of the 19th century. Box H.8·9cm. (3$^1_2$ in.), diam. 11·4cm. (4$^1_2$ in.). 02751 & A I.S. Cup H.4·1 cm. (1$^5_8$ in.), diam. 6·7cm. (2$^5_8$ in.). 02749 I.S. Bracelets diam. 8·2cm. (3$^1_4$ in.) & 8·9cm. (3$^1_2$ in.). 03159 & A I.S.

The sumptuousness of these articles, and the nine-stone ornament on the top of the box (see pl. 32) suggest that they may have been originally belonged to a member of the Burmese royal family or to a high official of the court. The box and cover (which originally contained two gold trays) may have been used to hold betel nuts.

The bracelets were for feminine wear. In Burmese female society jewellery has an unusually important place. As well as for adornment its possession also indicates the social status of the wearer both within the family, where it can confirm the maturity or relative rank of the daughters, or between families, when it is worn by the wife of the head of the household. Where there is a surplus of income beyond that required for daily needs it is often allocated to making religious donations, helping relatives and for buying jewellery for the female members of the family, dependents or servants. It is not unknown for a young girl entering service for the first time to be given a small item of jewellery such as a gold chain necklace or a simple bracelet. Although the younger women would now, perhaps, have different priorities, the number of pieces which formerly was regarded as conventional for important occasions, such as a wedding, ear-boring ceremony or government function came within the legitimate aspirations of older women. A complete set could be built up starting when a girl was quite young, beginning with hollow gold anklets. These would be followed by rings and bracelets and, equally important, several sets of five buttons for her jacket. In some cases these buttons were of gold set with diamonds, rubies or other precious stones. For the hair she would hope to acquire two hairpins and a comb each with inset precious stones, and for her ears a set of diamond studs. To complete the set, she would have had a narrow gold collar set with precious stones; below this would have been a double row of small pearls, then a tight necklace of thin gold chains and diamonds made in such a way that they trembled when the wearer moved and finally, below this, a gold locket and chain preferably also set with diamonds.

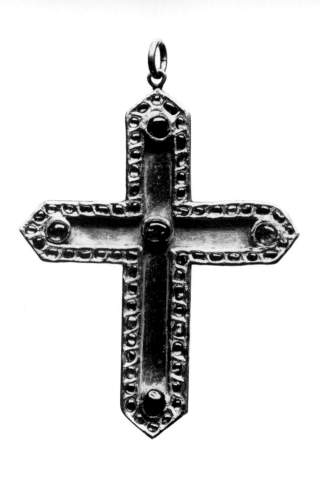

31 Pectoral Cross. Gold set with rubies. About 1870. H.9·2cm. (3 ⅝ in.). I.M.48–1932

This cross was specially made for a Bishop of the Church of England, Robert Milman, Bishop of Calcutta, by King Mìn-dòn (reigned 1853–78), who presented it to him in August 1870. Although given by the king, it was not presented to him personally and the circumstances surrounding this are an apt illustration both of the character of Mìn-dòn and the relations which existed between him and British visitors. Mìn-dòn was a deeply religious man whose convictions permitted a tolerant attitude to faiths other than his own. As a result he not only allowed Christian missionaries to work in Burma but also assisted them by subsidizing the building of their churches and other buildings. Bishop Milman arrived in Mandalay towards the end of July to inspect a clergy-house, schools (at which three of the king's sons were attending) and an unfinished church, all of which had been paid for by the king. He anticipated being presented to the king but, due to the sort of disagreements over protocol involving the question of seating arrangements which bedevilled Anglo-Burmese relations, the bishop and the king never met.

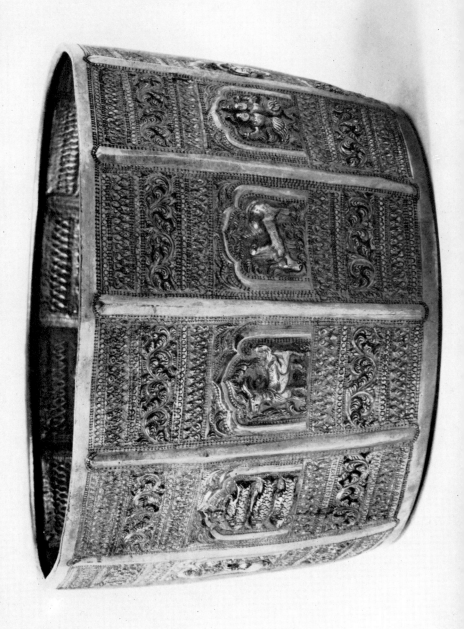

32 Ceremonial Bowl. Gold embossed with the signs of the Zodiac and with the nine-stone (*nawarat*) ornament at the bottom inside. Probably mid 19th century. H. 10·6cm. (4$^3_4$in.), diam. 18cm. (7$^1_8$in.). 02748 I.S.

The signs of the Zodiac were probably introduced into Burma from India, where the names of the mansions are given to the twelve solar months. Their signs are also similar, having only slight variations. On this bowl, for example, the Twins of Gemini are represented by two *kein-nayas* (*kinnaras*: see pl. 50). As in India and Europe, the Zodiac was used by astrologers in Burma to cast horoscopes, which formed an important part of Burmese life. Brahmans belonged to the palace staff, and part of their duties was the casting of horoscopes for members of the royal family.

The nine-stone ornament, which often appeared on objects associated with royalty (see also pl. 30), consists of the nine gems arranged with one in the centre and the other eight placed round it. Although it is difficult to establish a direct connexion between it and this ornament, the number nine has mystical properties in Burma, as it has in many parts of the world. This may be reflected by the Burmese word *ko*, which means both 'nine' and 'to seek protection by worshipping' although this could also be merely the result of both words being homonyms. In the worship of *Nats* both meanings are combined by the offering of nine candles and nine dishes of nine different kinds of food. Moreover, in the Kyauk-hse district of Upper Burma nine is regarded as an unlucky number which should be avoided. Also, in Burma, the seven planets are increased to nine with the addition of Ra-hú and Keik; these are slightly different in conception from the Hindu Ra-hú and Keik, from which they were taken. In a deified form, all nine play their part in the ceremony of the Nine Gods, in which eight are placed round Keik at the cardinal and intermediate points of the compass. This corresponds to an ancient idea (elaborated in the cult of the *mandala*) of placing a chief deity in the centre and surrounding it with four or eight, or more minor deities to form a group, the worship of which is regarded as being especially productive. It may be this idea which is partly responsible for linking eight of the planet gods (Keik is excluded) with the worship of Buddha by referring to them indirectly by calling the eight cardinal points round a pagoda by the names of the days of the week and Ra-hú.

In Burmese gold work the surface of the metal is sometimes left untreated as in this bowl and the objects shown in pl. 30. Alternatively it is sometimes stained red with tamarind juice.

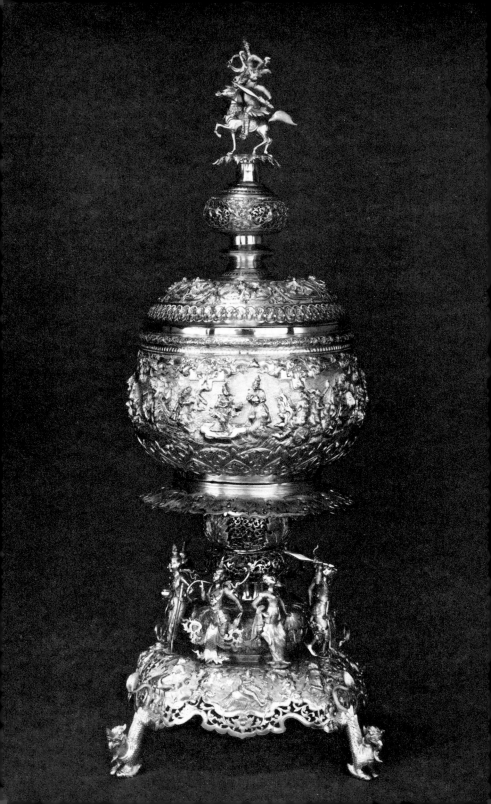

33 Table Centrepiece, consisting of a bowl and cover on a stand. Silver embossed and engraved and with figures of cast silver. Probably late 19th century. H. 85 cm. (33 $\frac{1}{2}$ in.). I.S. 19 to B–1971

The Victorian obsession with the improvement of industrial design, which expressed itself (amongst other ways) in the Great Exhibition of 1851 and the founding of the Victoria and Albert Museum, also made itself felt in countries which then formed part of the British Empire. Thus exhibitions of industrial art were held in India such as the Calcutta International Exhibition 1883–84 and the enormous Indian Art at Delhi Exhibition 1902–03. As parts of Burma were considered an extension of India for the purposes of administration for much of the nineteenth century, Burmese arts and crafts were included in these exhibitions. It is from the literature related to these exhibitions that much of our information about Burmese art at this period, including the names of craftsmen, is obtained. It is not surprising therefore that, from the way in which it was given official encouragement, this art shows unmistakable connexions with Victorian art at home.

This is shown quite clearly by the centrepiece illustrated in the plate opposite, and it would not be difficult to find comparable examples made in Britain about this time. Although much of the market for these pieces was among the European community and, therefore, there was an understandable tendency for craftsmen to produce pieces of Europeanized design, many traditional shapes and decoration were kept. The bowl which forms the main element in this centrepiece is based on the *hsùn-ok*, or monk's begging bowl (see pl. 34), while the bowl, stand and cover together are similar to a type of vessel (*kalat*) which was usually of gold and was used in royal ceremonies as a container for spices, fragrant woods or a handkerchief, etc.

Of the many skilful silversmiths who worked in Burma towards the end of the last century, it is possible that this centrepiece was made by Maung Yin Maung. As a young man in his twenties, about 1904, he submitted examples to several exhibitions, including a centrepiece similar to the one in this illustration.

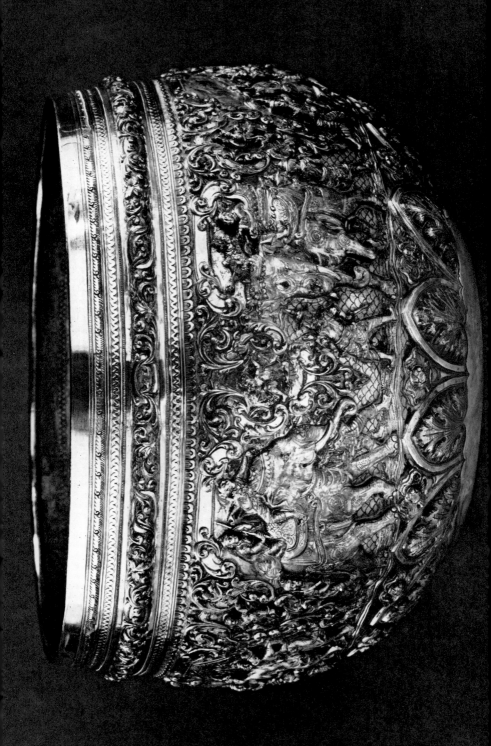

34 Bowl. Silver embossed and engraved with a battle-scene, perhaps from a Jataka story. Probably late 19th century. H. 19·7 cm. (7³₄ in.), diam. 27 cm. (9⁵₈ in.). I.S.368–1950

This bowl is similar to the one having a stand and cover shown in the previous illustration, and was probably made under the same conditions of European-inspired local craftsmanship described in the caption. Bowls of this shape have a long history in Buddhist countries, as they are conventionally regarded as being similar to the one which the Buddha used for receiving alms. The monk's begging bowl (one of the eight *parikkharas*, possessions which are allowed to a monk) which may be seen either held by the Buddha or a monk, is usually undecorated in Buddhist art. It may, however, have three rings round the rim and these are traditionally said to represent (with the bowl itself) the four stone bowls which, according to the Pali texts, each of the gods of the four directions presented to the Buddha. Not wishing to give offence to the other three by accepting one of them, he compressed all four into one. In some texts, however, the bowls were said to have been of sapphire, or gold, silver and precious stones. In Burmese silver ware, bowls similar to the one in the illustration are not confined to religious use but are made in various sizes for many purposes. In the best examples the embossing is restrained and the continuity of the metal is unbroken. In other cases attempts were made to raise the relief too high with the result that holes appeared in the metal, which had to be patched on the inside.

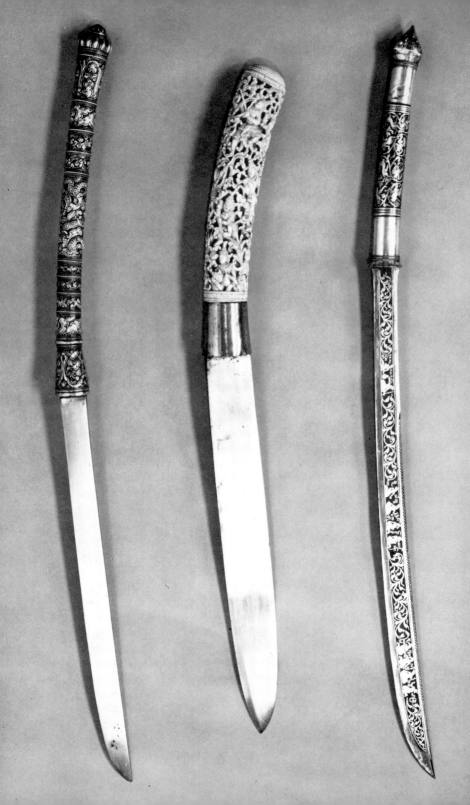

35 Three Swords. *Left*, with handle of embossed silver; *centre*, with handle of carved ivory and, *right*, with handle and blade of niello work. All probably 19th century. *Left* L. 85·1 cm. (33¹₂ in.) 24–1891; *centre* L. 71 cm. (29¹₂ in.). 2572 I.S; *right* L. 84·5 cm. (33¹₄ in.). I.S.236–1964

Given by Earl Kitchener of Khartoum

These weapons belong to the group usually described as *dà* in Burmese. This includes not only weapons for fighting but also knives for light chopping and trimming work such as clearing bamboo. *Dàs* usually have a narrow slightly curved, single-edged blade with either a tapering or a blunt point, and with a long grip without a guard. They may be intended for holding with two hands (left) or with one (centre). The blade of the weapon in the centre (*da hmyaung*) is somewhat unconventional, being straight and having the edge towards the inside of the curved handle. Sheaths are often of wood bound with metal; sometimes the wood may be covered with ornamented silver or silver-gilt as well as, exceptionally, being set with semi-precious stones.

The handles of *dàs* for fighting or ceremonial use are frequently decorated in various techniques. That on the left in the illustration is similar to the form of decoration used on the silver ware shown in pls. 33 and 34. The handle of the weapon in the centre illustrates Burmese ivory carving. This is often in highly complex designs involving, as here, a large amount of deep undercutting similar to that which is used in wood carving. In some of the ivory work, however, such as carved elephant tusks, the Burmese work approaches that of the Chinese in intricacy. The blade of the *dà* shown on the right of the illustration is deeply engraved, with the sunken areas blackened to leave the pattern of figures and foliage reserved against the dark ground. On some *dàs* decorated with this technique part of the exposed areas are gilt, thus creating an attractive design of gold, silver and black.

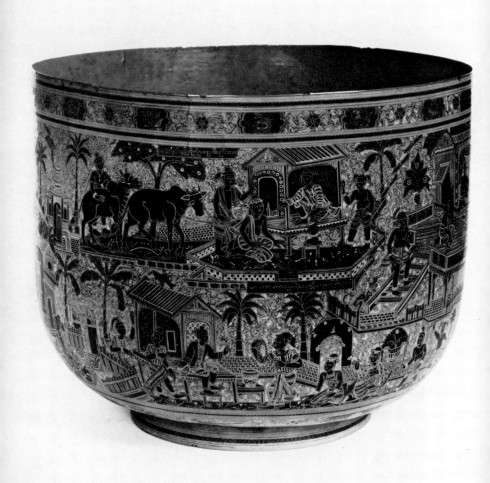

36 Bowl. Red lacquer with the design in black, yellow and green lacquer. Probably from Pagan; about 1910–20. H. 34 cm. (13 $^3/_8$ in.), diam. 23 cm. (9 in.). I.M. 57–1932

In common with other countries in East and South-east Asia, Burma probably made use of lacquer articles several centuries before the period to which the first dated Burmese example is assigned. This is a cylindrical box, rather similar in shape to the one shown in pl. 37, but having no decoration and said to be dated with a date equivalent to A.D. 1274. This early evidence of lacquer seems to be supported by an inscription which mentions lacquer objects and is said to have come from one of the Paw-daw-mu *thupas* at Pagan and, therefore, dates from about the eleventh century A.D. It is almost certain that the technique originated in China but the way, and also the period, in which it was acquired by Burma are uncertain. In all probability it came at different times and by more than one route. A clue to one of these is suggested by the name *yùn*, which is given to the type of polychrome lacquer shown in the illustration and is particularly associated with Pagan. The etymology of this word can be traced to the inhabitants of, and the area surrounding, the present town of Chiengmai in northern Thailand. During the Ava period Yun Thais are specifically mentioned by the use of the prefix *yùn* with the word *yò-dayà* (Ayudhya); moreover, lacquer workers were among the prisoners brought back to Pegu by Bayín-naung after capturing Chiengmai in 1558. It is possible, therefore, that a characteristic polychrome lacquer ware originating in Chiengmai was later taken up by Burma and the word *yùn-de* used to describe the ware from Pagan.

Distinction should be made between lac and lacquer. The former is derived from insects while the latter is obtained from trees. Burmese lacquer (*thit-sì*) is almost identical with the Chinese and Japanese variety but comes from a different species of tree, *melanhorroea usitata*. The method of manufacture is also somewhat similar. Lacquer mixed with paddy-husk ash is applied to a base made of bamboo basketry, wood or, for very fine work such as the bowl shown in the illustration, bamboo and horsehair, made in the shape and size of the article required. After enough has been added to give a smooth surface, a mixture of lacquer and colouring material is applied in thin coats, which are allowed to dry and are then polished before the next coat is added. In the lacquer shown in the illustration the pattern is then executed by filling incised designs with coloured lacquer. As well as black, other colours used in these designs are red, yellow and green.

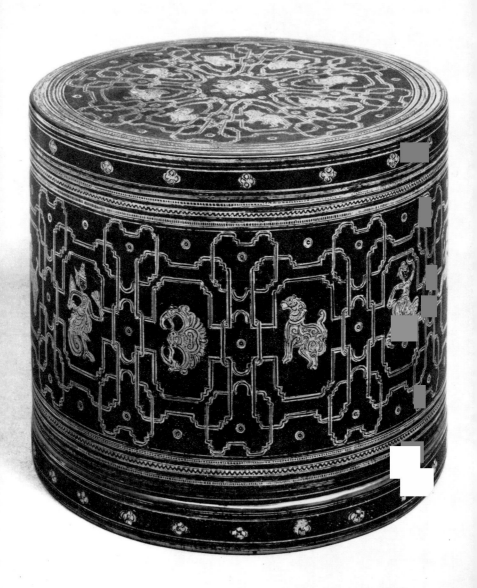

37 Nest of six Cylindrical Boxes and Covers, and one Tray. Black lacquer with the pattern in light red. Probably 19th century. H. 19cm. (7½ in.), diam. 22·2cm. (8¾ in.). 01330 I.S.

The method of manufacture and decoration of this nest of boxes is precisely the same as that described in pl. 36. As well as this technique lacquer may be decorated by the application of gold leaf to a black ground, giving either a gold design on black (see pl. 38) or the reverse; Prome specialized in this form of decoration. More recently silver leaf has been used in a similar way. Mandalay craftsmen were particularly skilled in making lacquer ware in relief (see pl. 39). In some cases the area in which lacquer is made has given its name to some of the articles which it produces. In Maùng-daung in the Mon-ywa district of the upper Chìn-dwìn the name of this small town is prefixed to the cylindrical boxes (similar to the one in this illustration) and lacquered bamboo bowls which were made there. Today Kyauk-ka in the same district and Win-gaba not far from Pagan are important centres for the manufacture of lacquer ware. In the Shan states it is made in Kengtung. During the monarchy workshops for lacquer (as well as other crafts) were established within the palace grounds.

Lacquer has many of the properties which are now associated with plastic. It is light, waterproof, easily moulded yet dries to a hard state and can be applied to almost any substance including metal (see pls. 1, 3 and 4) and stone (see pl. 8). In finer ware, such as the bowl illustrated in pl. 36, it remains flexible. The versatility of this material may be seen by the number of uses to which it was put in addition to those already mentioned. These include boxes and shrines (pl. 1), book pages and book covers (pls. 44 and 45), headgear (pl. 48), musical instruments (pl. 38), architecture (pl. 41), images (pls. 16 and 17), furniture (pl. 39) and for making coffins.

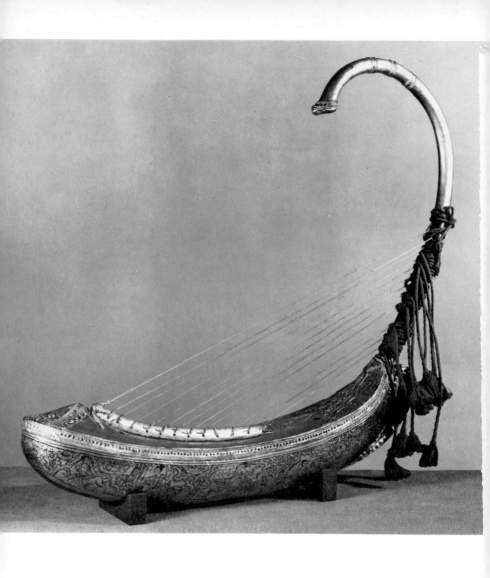

38 Harp (sauṅg-gauk). Lacquered wood decorated with scenes from the *Ramayana* in gold leaf and set with red, green and white mirror glass. From Lower Burma (Prome); 19th century. 61 cm. (24 in.), 72·5 cm. (32½ in.). I.M.234–1927

Bequeathed to the Museum by the Marquess Curzon of Kedleston

Harps of this shape have a very long history, similar ones being illustrated in ancient Egyptian art and on Greek pottery vessels. In Asia they are shown in the sculpture of Gandhara belonging to about the fourth century A.D. In Europe they were used until about the twelfth or thirteenth century when the triangle was completed by the addition of a strut, parallel to the strings, joining the soundbox to the post to which the strings were attached. In Burma, harps similar to the one opposite are shown in painting and sculpture at Pagan dating from about the eleventh or twelfth century. At this time they had six or seven strings but in the eighteenth century a further six were added, making the total thirteen, which has become conventional since that time. They are attached (in descending order from the longest string inwards) at the soundbox end to a wooden ridge and to the curved post by thick cords, which are then fastened to the post. The strings are tuned pentatonically in several ways, different pairs of notes being omitted from the heptatonic scale to suit the needs of different classes of piece. The instrument covers a range of two and a half octaves, the lowest string sounding the C below middle C, or a tone lower in some tunings.

In Burmese music the harp is often used to accompany the voice but its soft tone makes it unsuitable, as a rule, for combination with other instruments, such as drums, to provide music for dancing.

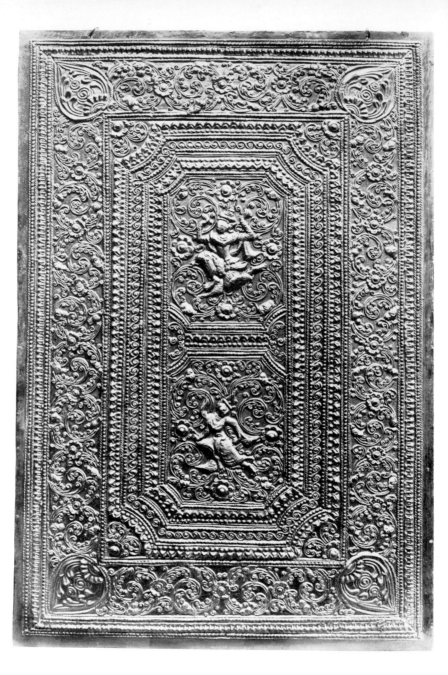

39 Panel from a Chest. Wood covered with black lacquer raised in relief. From Prome: 19th century. 45·5 cm. (18 in.), 30·5 cm. (12 in.). 2778–1883 I.S.

Although this panel was acquired in Prome it is more likely that it was made in or near Mandalay, where the craftsmen in lacquer specialized in making relief patterns. The technique is similar to that described in the caption to pl. 36 except that the areas in relief are modelled in lacquer that has been mixed with sawdust as well as the ash of burnt rice husk. The whole surface is then covered with finer, black lacquer and finished off in the usual way.

The design is in sharp contrast to those which are used to decorate the lacquer objects shown in pls. 36 and 37. This not only provides evidence of the versatility of Burmese craftsmen but also shows their mastery in handling complex designs involving the combination of figures and elaborate foliage motifs. This skill can also partly be seen on the silver bowl (pl. 34), the ivory sword handle (pl. 35) and the upper part of the shrine (pl. 2). But, above all, it is displayed at its best in the architectural wood carvings which decorate important buildings, palaces, temples and monasteries, such as the screens carved by Maung Hpò Thit for the Shwei-dagon pagoda mentioned in the caption to pl. 43.

In the nineteenth century chests in various sizes formed important items of Burmese furniture. Some, like the one from which the panel in this illustration probably came, were quite small and were used for storing more personal and important domestic objects, such as the jewellery mentioned in the caption to pl. 30. Larger ones for storing bedding and, in monasteries, books, were placed on stands supported by four legs and sometimes decorated with lacquer, or glass mosaic. Also, a small model of a building with a Buddha image inside could be placed on the top to form a shrine for family devotions.

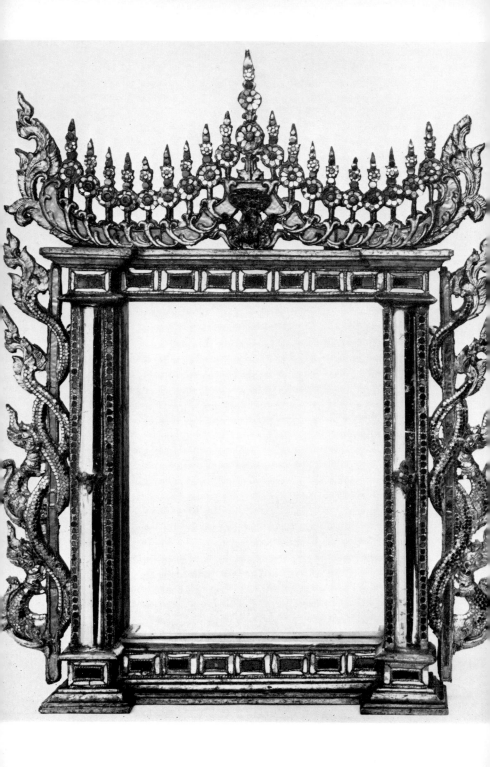

40 Mirror. Carved and lacquered wood set with coloured glass and pieces of mirror. Probably second half of the 19th century. H. 82 cm. (32 ³⁄₄ in.). I.S.7–1968

Given to the Museum by Mrs A. E. McKay

The treatment of the top of this mirror is closely related to a similar architectural motif found over the door of some Burmese buildings, such as the A-nan-da temple, Pagan. It therefore has a long history in Burmese art. It is also used for the decoration of doorways in the interior of buildings and above niches enclosing Buddha figures in shrines such as that shown in pl. 2. The motif in the centre of the top is a peacock, the emblem of the last reigning Burmese dynasty, and at each side are either two entwined *makaras* (mythical monsters which were taken over into Burmese art from that of ancient India) or a form of Burmese hybrid mythical animal called *tò-nayà*.

This mirror was taken from the palace compound of King Thi-bàw after the siege of Mandalay in 1885. It belongs therefore to the large group of relics from this campaign which have found their way to this country (see Cat. nos. 1, 29, 30, 32, 41, 45 and 47).

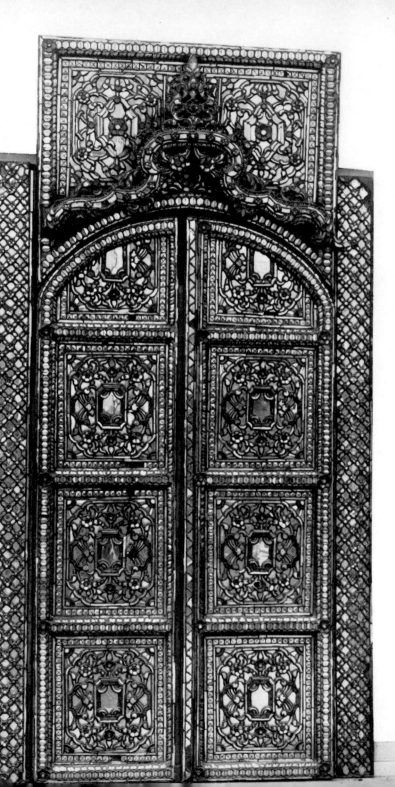

41 Pair of Doors and Door Frame. Wood, carved, gilt and covered with a mosaic of mirror glass set in lacquer. Said to have come from the Royal Palace, Mandalay. 19th century. 228·5 cm. (90$\frac{1}{2}$ in.), 122 cm. (48 in.). I.S.64–B–1959

Given by C. Grasemann Esq.

The sumptuous decoration of these doors suggests that they came from the palace itself rather than from some other building within the compound. The technique of decorating surfaces with pieces of coloured or plain mirror, set in lacquer, seems to have become particularly popular in Burma, and this may be judged by the fact that it is used to decorate ten other objects illustrated in this booklet (see pls. 1, 2, 3–6, 8, 16, 40, 45 and 48). It is probable that either the technique was introduced from Thailand during the eighteenth century, or was given fresh impetus as a result of wars between the two countries at that time.

It is not possible to say whether the doors shown in the illustration originally belonged to the inside or the outside of a building, as this form of decoration was used for both. In each case a profusion of glass mosaic must have created an overwhelming impression of magnificence and luxury. In an interior, particularly at night, walls, pillars and ceilings reflected from a dark background the small points of light given out by candles or oil lamps. On exterior surfaces, such as those on columns, architraves, walls and pilasters, each set at a different angle, the bright sunlight produced a continually changing kaleidoscope effect to the visitor as he approached the building or walked around it.

In most cases the technique of glass mosaic decoration was the same, whether it was used on small objects, such as boxes or receptacles, or for architectural ornament. A coating of lacquer mixed with a high proportion of sawdust was applied to the surface to be decorated. The glass, which had previously been cut to the correct pattern by using cardboard templates, was then covered with lacquer on the back and pressed into place. After the design had been completed, the gaps between the separate pieces of glass were filled in with more lacquer, having a consistency of putty, which was then lacquered again and gilded. For some exteriors a plaster or concrete base was used.

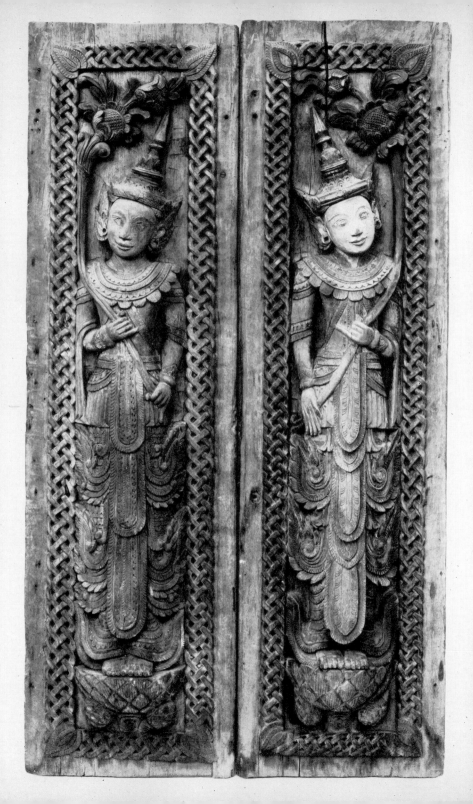

42 Two Panels. Carved wood with traces of painting. From Mìn-gùn, Upper Burma, probably mid 19th century. H. 120·5 cm. (59 $\frac{1}{2}$ in.), W. (of each panel) 42 cm. (16 $\frac{1}{2}$ in.). I.S.82 & 83–1954

These panels were probably each originally framed with ornamental borders to form two doors which may have belonged to a monastery building. Alternatively they may have been placed at each side of a doorway having doors carved with a different design. The figures probably represent conventionalized forms of minor gods (*devas*), whose presence helps to guard the entrance at which they appear. Sometimes they are supported, as here, on lotus blossoms alone while in other cases the lotus plant may itself be held or supported by a grotesque, animal-like figure (*bàlù*; see pl. 9). In nearly all cases the figures wear the costume, falling in three tiers of panels and up-turned loops from the waist, which is usually associated with deities (including some *Nats*) and royalty (see pls. 11, 16 and 43).

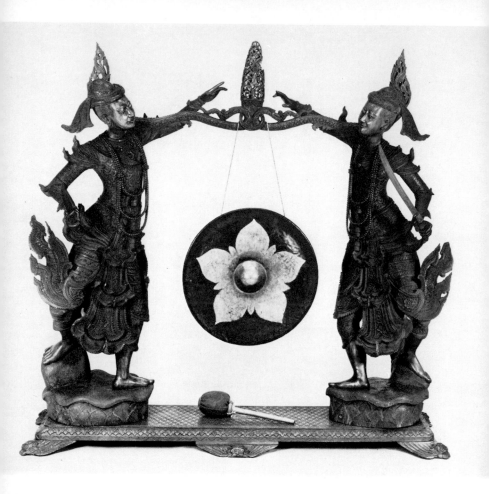

43 Gong Stand and Gong. Stand of carved wood: gong of embossed and gilt brass. From Rangoon; late 19th century. 175·2 cm. (69 in.), 180·3 cm. (72 in.). I.S.35 to E–1972

An inscription carved on the base of the stand gives the name and address of the carver who made it, *Maung Hpò Thit Godown Road No.23 Rangoon*. This carver was well known and regarded as one of the best who worked in Rangoon. Although it is not known when his career began, as this stand and gong were acquired at Mìn-hlá in 1885 it is clear that by then he had become a highly skilled craftsman. Maung Hpò Thit carved some of the decorative woodwork forming part of a screen in the Shwei-dagon pagoda in Rangoon. This he later copied and sent to the exhibition of Indian arts and crafts (which included those from Burma), held in Delhi in 1902–03, when it was sold for 3,000 Rupees. It is not clear whether his work was submitted as part of the competition but, at all events, he was not awarded a prize. It is clear from this piece of carving that he was a master craftsman of superlative technique. Figures, which are full of life and movement, are surrounded by foliage, flowers and tendrils, the whole design being handled with the most consummate assurance and control.

Such skill by Hpò Thit and many others can only have been the result of a long tradition of wood carving, mostly in teak. This was provided by the convention of architectural decoration using this technique, both for the interior and exterior of buildings. Thus, not only palaces, but also monasteries and dwelling-houses belonging to the more wealthy were ornamented with elaborate wood carvings which were sometimes painted and gilt. An example from a pair of monastery doors is shown in pl.42, and some idea of the effect given by architectural woodcarving can be seen in the painting illustrated on pl.46.

In the latter part of the nineteenth century craftsmen were encouraged to employ their skill in the making of objects for sale to Europeans, for whom the late Victorian taste for elaborate ornamentation had created a predisposition towards the intricate designs which were so suited to Burmese skill. Gong stands similar to the one in the illustration and in other designs were extremely popular, as well as furniture, screens and picture frames, etc., etc. These, and silver-ware such as that shown in pl.33, appliqué embroideries similar to that shown in pls.25 and 26, and other *bric-à-brac* were sold in shops which specialized in Burmese handicrafts such as those belonging to Messrs F. Beato Limited, who had premises in both Mandalay and Rangoon.

44 Cover, Back and Front of Page of a volume of religious regulations (*Kammavacha*, B. *Kamawas*). Lacquered wood. Probably 19th century. L. 55·9 cm. (22 in.), W. 14 cm. (5$\frac{1}{2}$ in.). I.M. 85–1912

Kammavachas form nine *khandhakas* (extracts) from the Pali Vinaya. They contain formularies relating to specific transactions which take place at meetings of the monks' Chapter or Order, such as the ordination of a monk, his investiture with the three robes, the election of an elder, the dedication of a monastery, etc. In Burma the Pali text is written in square Burmese script (shown at the top of pl. 44). A novice who intends to enter the order may be given one or a number of volumes by his friends or relatives as a present to mark his ordination.

The covers of *Kammavacha* volumes are usually of wood with the decoration carried out in red, black and gold lacquer (bottom illustration). The pages are also wood decorated in the same way, or of lacquered strips of cloth or basket-work (in a technique similar to that described in the caption to p. 36). Pages may also be of lacquered thin brass sheets, ivory, or of black wood inlaid with mother of pearl.

The pages are loose, being unbound, and are read horizontally, each page being turned away from the reader as it is finished and the next one commenced.

45 Folding Book (*parabaik*). The cover decorated with gilt lacquer set with coloured looking-glass. From Mandalay; dated A.D. 1881. 17 cm. (6$\frac{3}{4}$ in.), 39·5 cm. (15$\frac{1}{2}$ in.). I.M.127–1918

This book is one of two presentation volumes of verses (*eì-gyìn*) extolling the glorious achievements of past ancestors, as well as cradle songs, music and eulogies to be recited and sung to the eldest daughter of King Thi-bàw and Queen Súh-payà-lat on the occasion of placing her in the emerald cradle on the 10th day after the new moon of the month of Nadaw in the Burmese year 1243 (A.D. 1881). They were presented by Mìn-gyì Thadò Thú-dama Thet-taw-shei Chief Minister and governor of Le-gaìng (also known as Kìn-Wun Mìn-gyì) and Mìn-gyì Mìn-Htin Si-thu, Wun-dauk (Assistant Minister) and governor of Wet-masut.

The pages of a *parabaik* are joined on each alternate long edge so that they fold up like a map. The book is placed horizontally in front of the reader, who turns the pages away from him; after the last page has been read, the book is turned round and the procedure continued. Pages can be, as here, white in colour and the text written in black ink. More conventionally, perhaps, the pages are covered with a slightly rough black ink and the writing executed with a steatite pencil. This combination is similar to a slate and slate-pencil, since the writing can be rubbed out and the pages of the *parabaik* used again. An illustration from a *parabaik* (in which the folds are vertical) is shown in pl. 46.

The relief lacquer decoration on the cover is similar to that used on the shrine shown in pl. 1 and the panel shown in pl. 39, while the inlay technique is also similar to that used on the doors illustrated in pl. 41.

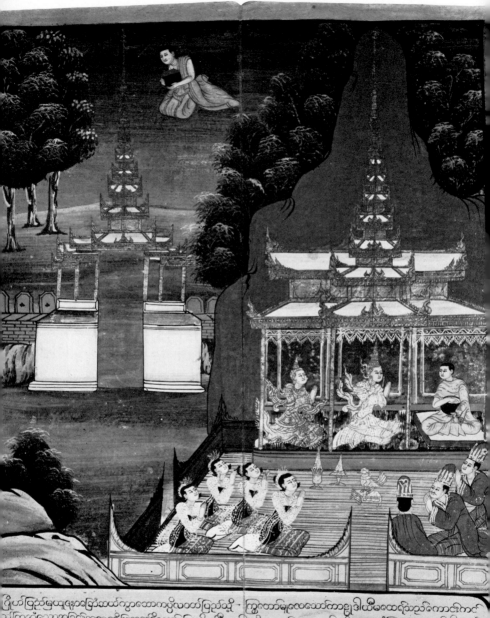

ပြိုဟ်ပြင်မှယူ၍နောက်မှာသယ်ကွာတောကပ္ပိလဝတ်ပြည်သို့ ကျွတော်မျလေသောကအစွဲ၌ယ်မထေရ်သည်ကောင်းကင်
ညိကျွံ့သိုသောအခြင်းအရာ့ကိုပြည့်ရှိသော်မကြွပါ၌ဦးဆ ကိုသာဘုန်းပေးတော်မျပါဟုလျှော်ကြားသောအခါပါသည်
လွှတ်တော်မူ၍ပြုံကူည့်လလျှင်အလျှန်ဒုံ့ကက်သည်ပြ၍ ၍အရှင်ကာခွပါ၏ယူဘုရားသခင်သည်ဤ၍မြို့သို့ရဲသည်တိုင်
ဘားစိုက်၍မည်းတော်သူဌ္ဌ၍ဒဗူမင်းကြီးဖ္ဌ၍ဆွမ်းကိုသာဘုန်းပေးတော်မူဟာန်။ ၁၁၅ ။

46 Illustration from a Folding Book (*parabaik*). Gouache on thick paper. Probably late 19th century. H. 20 cm. (7⁷₈ in.), W. 26 cm. (10¹₄ in.). I.S.8–1955

Given to the Museum by Lt.-Gen. Sir Euan Miller, K.C.B.

The volume from which this painting is taken contains illustrations of incidents from the *Nidana-katha*, which is the introduction to the *Jataka* stories (see pl. 22), and may be part of a set of several volumes comprising this introduction. This is suggested by the number 115 occurring at the end of the relevant portion of the text, which, since it is far greater than the number of illustrations in the book, seems to indicate that there were other volumes in which the lower numbers appeared. The *Nidana-katha* and the *Jataka* stories are popular subjects for Burmese illustrated books, many of which have found their way into European collections. The style, while evidently owing much to late Indian painting, has markedly national characteristics, which make it unmistakably Burmese. These can be seen in the conventional rendering of a mountain and of architecture, which is treated in a two dimensional way similar to theatrical scenery.

The translation of the text which relates to this illustration, and part of which can be seen at the bottom of the picture, is as follows:

'Afterwards, the Elder Kaludayi said, 'Reverend sir, the royal father, the great king Suddhodana has reached old age and wants to see the face of your reverence.' Thereupon the Buddha, surrounded by all the monks, left the city of Rajagaha for the city of Kapilavatthu, a distance of sixty leagues. The Elder Kaludayi went ahead by flying through the air to the city of Kapilavatthu. On arrival there the great king Suddhodana seated him in a place of honour, filled a bowl with food and presented it to him. When the Elder Kaludayi appeared to be leaving, the king said, 'Please do not go away as yet. Please eat the meal first'. When the Elder replied, 'I am taking away the food to the Buddha to eat', the king asked, 'Where is the Buddha?' On receiving the reply, 'The Buddha has left Rajagaha today', the king was extremely glad and said, 'Reverend Kaludayi, please feed the Buddha with my food every day until he arrives at this city.' These are the scenes depicting the Elder flying through the air to present the food to the Buddha taking only the food presented by the royal father on the journey. 115.'

This story can be found in the translation of the *Nidana-katha*, which forms part of *Buddhist Birth Stories*, by V. Fausboll and T. W. Rhys Davids, 1880, pp. 121–22.

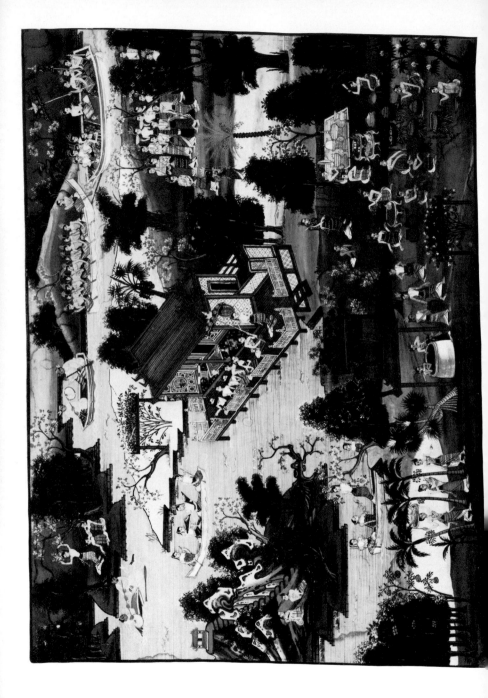

47 Painting of a Pastoral Scene. Gouache on paper. Late 19th century. 50·8 cm. (20 in.), 68·6 cm. (27 in.). I.M.1–1941

This picture was said to have come from the royal palace at Mandalay and may represent a picnic taking place in the palace grounds. The absence of fold marks, the ornamental gilt frame which surrounded it and the glass which covered this picture suggests that it was probably not a book illustration such as that shown in the previous plate. It is likely, therefore, that it was painted especially to be hung on a wall as part of the interior decoration of a room. It can thus be considered as the equivalent of a European easel-picture or water-colour painting and may be the result of a desire to adopt the European custom of hanging pictures on walls as a form of decoration.

In style and technique it is, however, entirely Burmese. Perspective is obtained by using a high viewpoint and raising the horizon nearly to the top of the picture so that the result is almost a bird's eye view. This was a traditional device which enabled painters to show several related and consecutive incidents within the boundaries of the same picture (as in the previous plate). Here, however, only one is shown. At the top a prince, or other member of the Royal family (identified by an umbrella), is being carried by boat to meet a princess (also identified by an umbrella) in a pavilion which is set on the bank of a river or by a lake. Behind the pavilion servants and entertainers wait in a grove. In the foreground (left) food is being brought, water raised from a well and on the right cooks are preparing the meal under the direction of a supervisor. On an island opposite the pavilion there is a small shrine on top of a low hill up which runs a flight of steps. A humorous element is added by an incident at the top left hand corner, where a boat has upturned its occupants into the water and amused three girls who are sitting on the bank.

Although somewhat stylized in execution, particularly in the representation of rocks and water, this picture is remarkable for the accuracy of its details. This is most noticeable in the artist's observation of nature. Each of the trees and plants can be easily identified with a species common to Burma; these include coconut palms, areca palms, the 'flame of the forest', papaya, and orchids which can be seen trained between frames.

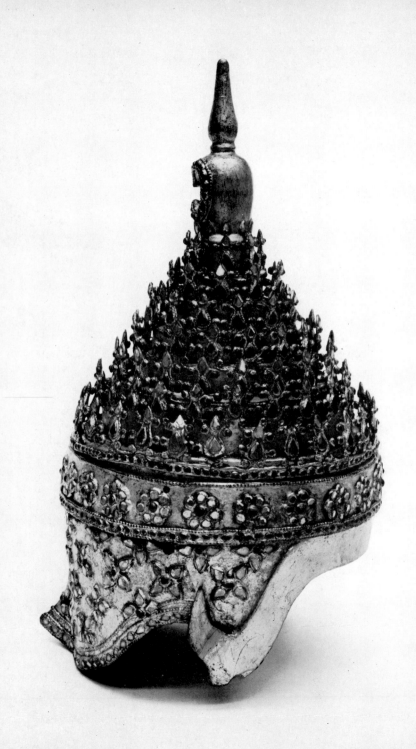

48 Headdress. Wood lacquered and gilt, and sheet metal set with pieces of mirror and imitation stones. Probably late 19th century. H. 36·8 cm. (14 1/2 in.), diam. 21·6 cm. (8 1/2 in.). 06207 I.S.

This headdress was probably intended to be worn by a young girl for a theatrical performance of either a play or dancing. Its shape is highly conventional and is similar to the crowns worn by Jambhu-pati Buddhas (see pls. 2, 12 and 16), royalty (see pl. 46) and minor dieties (see pls. 11 and 42); it is also similar to the finial (*hti*) which is placed at the top of Burmese pagodas. The first Burmese Court play was probably written by Padei-thá Ya-za between 1714 and 1733. Theatrical performances (*pwè*) therefore, seem to have been a late development in Burmese culture (see pl. 49) coming after, and being influenced by, the puppet shows. However, the gradual acceptance of men and women appearing together on the stage en-abled the theatre to develop into a popular form of entertainment. As in the puppet shows, the stories are mainly based on the Jataka tales (see pls. 22, 25 and 46) or incidents from Burmese history and illustrate the triumph of virtue over vice, through the characters of a prince and princess. The hero and heroine are idealized, senior officials are lampooned, and comedy is provided by rustic figures who play the role of a clown or jester. Topical references are included in the dialogue, which frequently includes coarse jokes. Spice is also added by the rich capacity of the Burmese language for creating double meanings. Perhaps the nearest equivalent in the West would be the unlikely combination of an Old Testament story, or one of the lives of the saints, treated in the form of a pantomime.

Nowadays theatrical performances take place on a raised bamboo stage erected for the occasion and equipped with lighting and cur-tains. In the past, however, they were held in any convenient open space which was large enough, such as a street, a large garden or the space surrounding a pagoda. It was first swept and then mats were put down for the actors or dancers to perform on; tables and racks for masks and other objects required for the play were placed in a convenient position close to it. There was no convention simi-lar to that in the West which usually prevents actors from being seen by the audience except when they are performing. Music from an orchestra accompanies the songs and dances and underlines the plot. A single performance often lasts all night and it may take three performances to complete a play.

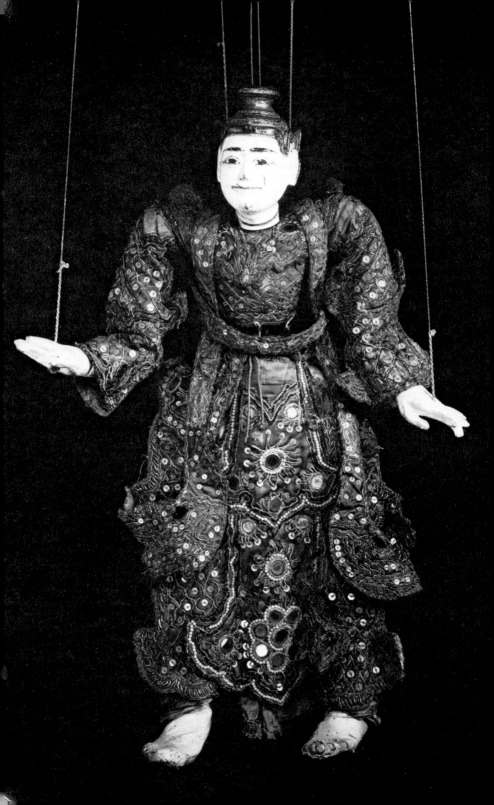

49 Puppet Figure. Carved and painted wood and with a costume of dark orange silk embroidered with gold thread, sequins, pieces of mirror and glass beads. From Mandalay; late 19th century. H. 63·5cm. (25in.). I.S.33–1966

Puppetry, with figures similar to the one in the illustration, has been popular in Burma since the latter part of the seventeenth century. This is in contrast to shadow puppetry, which seems to have been less popular than in neighbouring Thailand and Malaysia.

The origin of puppetry in Burma is obscure; it is evidently a foreign technique but which of the two adjacent countries with puppet traditions (India and China) it is more likely to have come from is now difficult to say. In spite of its comparatively late development in Burmese cultural history, puppetry (*yok-thei*) preceded drama (see pl. 48) and has not only influenced it but also probably been more popular. This may have been partly due to the social convention that prevented unmarried men and women from appearing together on the stage, which hindered its development. But, whatever the reason, puppetry shows were considered to be a serious entertainment for adult audiences rather than for children, as in the West. Puppet shows were patronized by the Burmese kings, who had an official (*Thabin-wun*) at Court who was in charge of performances. The themes of the plays are taken from the stories of the Buddha's previous births (Jatakas) and incidents in Burmese history. As well as providing entertainment these had a moral element, such as the triumph of virtue over vice, and acted as an outlet for popular comment on current affairs.

Performances take place on a raised stage above which a curtain screens the puppeteer and upper strings of the puppets from the view of the audience. At one side of the stage a throne and palace interior is shown, at the other side a few branches represent a forest, both scenes being conventional in all stories. The traditional group of puppets is 28, which includes animals, courtiers, a king, a prince and clowns, etc., but it may comprise more or less than this. The puppets are divided into two main groups on the stage, the Left Puppets and the Right Puppets. It is the responsibility of an assistant puppeteer to ensure that they are correctly placed and immediately available, and of another assistant to manage the rest of the stage. The puppet master was thus left free to extemporize the dialogue and sing; an orchestra placed in front of the stage accompanied the songs and provided incidental music.

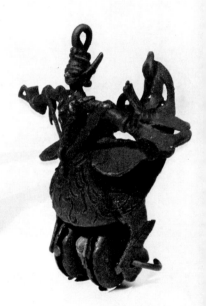

50 Two Loom Pulleys. *Left*, of wood in the form of a sacred goose; *right*, of metal in the form of a *kinnara*. From the Katha district, Sagaing Division; probably 19th century. *Left*, 16·5cm. (6$\frac{1}{2}$in.), 7cm. (2$\frac{7}{8}$in.). I.M.73–1922. *Right*, 11·5cm. (4$\frac{1}{2}$in.), 6·7cm. (2$\frac{5}{8}$in.). I.M.75–1922

These pulleys were used on hand looms to suspend the heddles, which, by raising half of the warp threads alternately, enabled the weaver to form the fabric structure.

The sacred goose (*hamsa*) is described in the caption to pl.29. *Kinnaras* are mythological hybrid creatures which are half human and half bird. They have a long history in Indian literature, being mentioned among some of the lists which are given of the eight classes of demigods thought to exist in addition to the worlds of gods and men. In Indian art they are shown in sculpture of about the first century A.D. on the great *thupa* gateways at Sanchi. In South-east Asia they are sometimes regarded as feminine (*kinnari*). This seems to be emphasized in the literature of the late eighteenth century in Burma, where they are described as having gentle manners, eating only the pollen of flowers and being endowed with five kinds of beauty, which were those of the flesh, bone, complexion, hair and voice. At the Buddha's Enlightenment they were said to have danced for joy.

In spite of these pulleys being in the form of creatures mentioned in ancient texts they could also be regarded as examples of folk-art. In this respect they belong to the same category as the bronze representation of the Buddha descending from the Tavatimsa heaven shown in pl.14. Both belong to a style of Burmese art which, while often representing sophisticated subjects, is executed in a somewhat rough and ready manner more characteristic of the village workman than the highly-skilled craftsman of the towns. In the villages, moreover, local styles were frequently influenced by the more obvious folk-arts of the ethnic sub-groups, such as the Karens, Kachins, Chins and Shans, which form the Union of Burma. Although this political grouping is comparatively recent, for most of Burma's history there has been a pool of folk-art in the remoter districts in addition to the art of more sophisticated minorities, such as the Mons, and Chinese and Indian immigrants, which have made their contribution to the various styles forming the development of Burmese art history.

Index